Portrait Drawing Techniques

70.640

Overleaf
DAVID HOCKNEY 1937–
Carlos 64·8 cm × 53·2 cm–25½ in. × 19¾ in.
Brown and black pencil crayon on white ground
Reproduced by courtesy of the Knoedler Gallery, London

Very often drawings appear to be unfinished. The artist concentrates on those aspects that interest him particularly – he may have done everything he feels to be necessary for his purposes. But whatever the reason, an 'unfinished' drawing such as this can give useful information about the way the artist works. Hockney is precise and decisive in his use of line right from the start – there are no hesitant woolly strokes. I have never found this medium easy to use, but pencil crayons (the type with which my teachers marked my sums) are easily available, refuse to be rubbed out and do not smudge

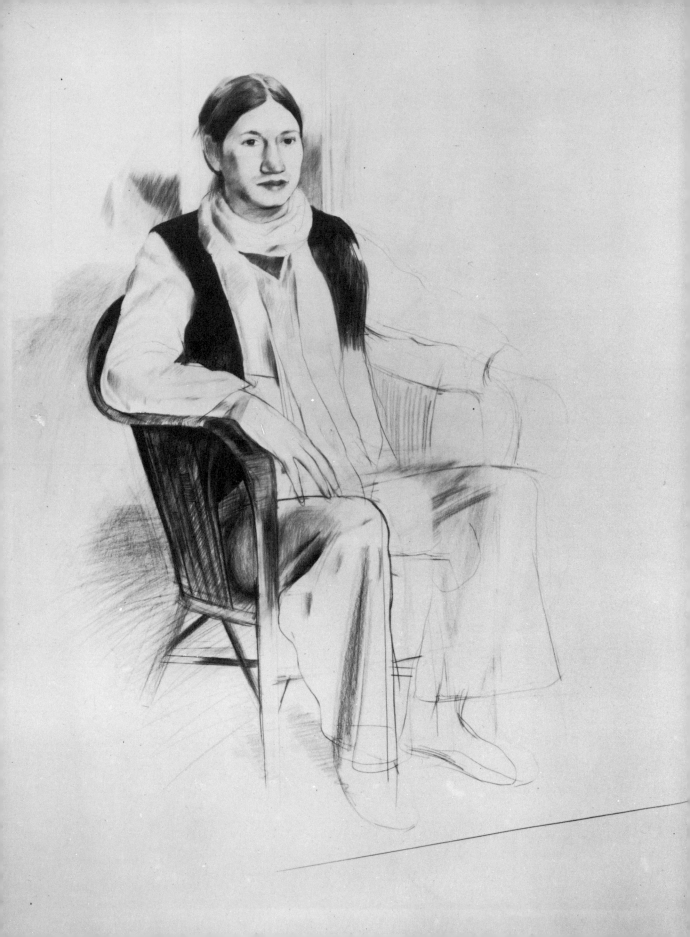

Portrait Drawing Techniques

Dianne Flynn

B T Batsford Limited London

First published 1979
ISBN 0 7134 1066 3

Filmset by Filmtype Services Limited
Scarborough, Yorkshire
Printed in Great Britain by
Wm Clowes Ltd,
Beccles, Suffolk
for the publishers
B T Batsford Limited
4 Fitzhardinge Street
London W1H 0AH

Contents

Acknowledgment

I would like to thank Thelma M Nye for her help and guidance, especially the trouble she took to obtain the more obscure illustrations. My thanks are also due to the members of staff at the Witt Library, Courtauld Institute of Art for their assistance in my research, and also to Jay Melrose-Woodman for reading the typescript and making some useful suggestions. Above all I must thank my husband, Paul Hedley, who has taught me a great deal and without whose help this book would never have been written.

For permission to reproduce the master drawings in this book I am indebted to the following:
The Art Institute of Chicago 79
The Trustees of the British Museum 39 colour plates facing pages 72 and 73
Museum Boymans – van Beuningen, Rotterdam 96
The Burrell Collection, Glasgow Art Gallery 15, 55
Cincinnati Art Museum 97
Courtauld Institute of Art 68
Davis and Long Company, New York 115
Dover Publications Inc, New York 77 and colour plate facing page 96
Groninger Museum, Holland 94
The Isabella Stewart Gardner Museum, Boston, Massachusetts 69
Knoedler Gallery, London 2
Kunsthalle, Hamburg 48
The Kunstmuseum, Dusseldorf 38
Lénars, Paris 21
Henry Moore 107
National Gallery of Art, Washington 42
The Trustees of the National Portrait Gallery, London 14
Anthony d'Offay 86
The Ormond Family 114
Sir John Rothenstein 86
Staatliche Museum, Berlin (West) 61
Sterling and Francine Clark Art Institute, Williamstown, Massachusetts 35
The Wadsworth Atheneum, Hartford, Connecticut 41
The Trustees of the Victoria and Albert Museum, London colour plate facing page 97

London 1979 DF

Introduction

Reproductions of great drawings are readily available and these can be used as part of the process of learning to draw. There is a great deal of free instruction to be had just by looking at the drawings, and I hope to show how such material can be used. So, besides the drawings I have prepared myself, I have included examples of Masters, Old and not so Old, with comments in each case chiefly about how the drawing was done.

Looking at pictures
When looking at works of art, do not always look just to enjoy but to learn as well. Ask yourself: 'How did he do it?' Look closely, try to imagine you are doing the drawing – 'feel' the pen or chalk moving across the surface of the paper – try to guess in what order the marks were made – where the drawing was started. Can you see lighter more tentative marks underneath the final finished lines? or any corrections? Take any opportunity that arises to look at the originals. Much detail can be lost in reproduction and, more often than not, the scale is altered too. Most books give the dimensions of the picture, and this is essential to our understanding of it. After all, working on a very large drawing requires a different technique from doing a small one.

Copying from the Masters
Copying works we admire is an excellent way of understanding them. But do not copy blindly; try to reconstruct the drawing step by step. Copying has fallen into disrepute of late, but it used to be an important part of learning to be an artist. Rembrandt asked his pupils to copy his drawings stroke for stroke Rembrandt himself copied Raphael, who in turn copied Leonardo da Vinci.

Then again, if there is a painter you particularly admire look for as many of his drawings as you can and note his progress and development. You may find it helps to try doing your own drawings in his style, using his techniques. Experiment and see if you can find out how he arrived at a particular effect. You can analyse a drawing in this way only if you have had a certain amount of experience and have learnt how a particular material behaves. Some drawings are more difficult to analyse than others. Like anything else, you improve with practice and you will find it is a skill well worth acquiring.

General points about drawing

What is a drawing?

What exactly is a drawing as distinct from a painting? For the purpose of this book, a drawing is basically tonal, that is to say, it does not take account of the colours of the subject, only of the darks and lights. This is just a working definition, it is not meant to be taken as a hard and fast rule. A drawing may be in black and white, it may use two or three colours, it may be done on coloured paper. Any colour that is used, is used simply for its tonal value. For instance, many Masters have used black, white and red chalk on a grey ground. On the tonal scale, red happens to be lighter than black so in this combination we have a clear scale of four distinct and different tones (grey being included as the fourth).

Rules

As far as I am concerned there is only one rule to follow in drawing: you have to be comfortable. You cannot concentrate if your arm movements are cramped or if you feel awkward or off-balance. You must be relaxed, with your materials where you can reach them easily without stretching. Make sure also that you are not working in your own light! All this seems to be common sense but I have seen so many people who ignore this basic rule and make things difficult for themselves. If you are doing a large drawing, work standing up at an easel. If you are sitting down, tilt your drawing board against a table or the back of a chair. Remember to take into account your distance from the subject. If you feel compelled to record every wrinkle, it's no use being so far away that you cannot see them.

Your subject

It is most important to have an interested and patient model, especially when you first start doing portraits. Sitting still for long periods is unnatural, so remember to give your model regular rests. On the other hand, it can be stimulating to have a rather fidgety model, because it keeps you on your toes. Organise things so that you have enough light on your drawing as well as on the model. I know this can be tricky, especially if you pose the model against the light, but use your imagination and be flexible when setting up a pose. If you get half way through a drawing and find you are thoroughly bored, the chances are that your drawing will be boring – so scrap it, choose another angle and start again.

Self-portraits have certain advantages, but there are pitfalls to beware of. Try to organise yourself so that you move your head as little as possible because you will find it difficult to get back into exactly the same

position every time. The easiest way is to have the mirror and your drawing side by side on an easel, but if you get fed up of full-face portraits, you will find you can work wonders with two mirrors and a little ingenuity.

Drawing from photographs

Perhaps you cannot find enough people who are willing to sit still while you draw them. It is restricting if you can only draw the same two or three people all the time. It is useful to practice with as many different facial types as possible. Using photographs for reference is by no means as stimulating as drawing from life because the contrast is often exaggerated and the tonal subtleties are lost but it is certainly better than not drawing at all. Degas, Whistler and Sickert are only a few artists who made use of photographs. Working from your own snapshots can also give you ideas for compositions, for looking at people from unusual angles, and they can encourage you to be more adventurous in your approach to portraiture.

Drawing from memory

The great Chinese landscape artists would stand on a mountain top and spend hours simply absorbing nature. Later, indoors, they would make their drawing which combined the elements of nature they had seen and a distillation of their mood and feelings on that particular view. The students of drawing in Paris in the middle of the last century would often be taken to the Louvre by their tutor where he would point out various masterpieces. On their return to the studio, they were expected to produce, from memory, faithful copies of what they had seen. Working from memory is not easy, but it certainly helps to make you more observant.

Starting

Draw yourself in varying positions and lights and use as many different media as you can. If you have made a good drawing you have proved you can do it. If you make a mess it is not proof you cannot do it. Most beginners lack self-confidence. If you want to draw well, you will — albeit clumsily at first — but only by doing it, not by thinking about it, or reading about it. It amazes me how many people appear to be affronted because they cannot draw well after the first two or three attempts. It takes time and effort to acquire any skill and when you have acquired the skill it does not follow that you have ended there. I think it was Degas who said . . . 'drawing is not very difficult when you don't know how, but when you know . . . oh! then it's another matter'.

How the book is arranged

For the sake of convenience I have divided the book into sections, each dealing with a particular medium: chalks; charcoal; pencil; pen and ink; wash and watercolour; oils. In each section I have included examples of Master drawings, and of my own works, in an effort to show the variety of ways in which each medium can be used. The illustrations have an introductory text which deals briefly with the particular characteristics of the medium, the most suitable type of paper to use, and any other general points that need to be made. I do not wish for a minute to give the impression that these sections have to be treated separately – that chalks must not be used with pen and ink for instance, or charcoal with watercolour. The more you experiment with combining different media, the wider will be the range of possibilities at your command, so I have included a number of examples of mixed media drawings that might give you some ideas.

Chalk

This first section deals with chalks (conté crayon and pastel) and I give below a description of what they are and the paper you might find useful.

Conté crayon
Many art books about Master drawings have captions to describe the picture and you will see 'medium: black chalk or crayon'. We know that chalk is usually white and if we went into a shop and asked for black chalk we probably would not get very far. The black chalk referred to was a natural slate known as carboncino. The nearest thing you can get to that nowadays is black conté crayon, which was developed in France towards the end of the eighteenth century. It is simply black pigment bonded with Monsieur Conté's formula and formed into straight sided sticks. Besides black, it comes in red (sanguine), brown (bistre) and white as well as in a range of greys. It is also available in pencil form. I find it a most useful and versatile drawing medium.

Pastel
This is a softer and more powdery medium because the pigment is not bonded with any kind of gum or wax but is simply compressed, extruded and clipped into manageable lengths. It produces a different sort of line from conté crayon and I find it more difficult to control with precision when working on a small scale. On the other hand, because it is softer it moves more freely over the paper and, with it, it is much easier to produce intense darks or lights. Soft pastels come in a vast variety of colours and tone, but when I am using a full palette the 'pastel' then comes into the category of painting which is outside the scope of this book.

Paper
You can use pretty well any surface for chalk drawing (including canvas and board as well as paper) as long as it is not too smooth and shiny. I prefer to use Ingres paper which has a good texture, and 'holds' the chalk well – this is especially important when working with pastel which tends to get rather smeary on smooth paper. I do not like using rough watercolour paper for portraits because it seems to produce a fuzzy effect. Ingres paper has a crisp regular texture that brings out the best in chalks. However, it is a matter of personal taste. Certainly for quick sketches in conté, cartridge or sugar paper is as good as anything, but if you are going to spend some time on a drawing and apply a good deal of chalk, you will need a surface with a little more grain.

Fixative

It is as well to fix your drawings when they are finished so that the chalk does not get smudged. Fixative can be applied with an aerosol or a spray diffuser, and several light coats are better than one heavy one. When storing chalk drawings it is best to inter-leave them with tissue paper. In fact they are surprisingly durable but if you want to give them extra protection you could mount them and cover them with polythene or 002 gauge acetate. You can see what a good mount looks like in any gallery and it is not all that difficult to do yourself. Try a few on sugar paper first before you start on expensive mounting card and always use a knife with a really sharp blade.

Kneadable putty rubber

I always keep a piece of putty rubber in the palm of my hand whilst drawing in pastel and charcoal. When it gets warm you can knead it then manipulate it into a blunt point and use it to 'draw' lights into your work. The putty absorbs the charcoal or pastel dust and lifts it off the paper. When you use an India rubber eraser you are in fact rubbing away the top layers of the paper.

GEORGE RICHMOND 1809–96
Detail of *Charlotte Bronte* 55·8 cm × 44·4 cm—22 in. × 17½ in.
Black, red and white chalk on light fawn paper
Reproduced by courtesy of the Trustees of the National Portrait Gallery, London

Many of Richmond's portraits can be seen in the National Portrait Gallery, London. The paper he used was fairly smooth, as can be seen from the tracery of fine lines which follow the form. Red chalk has been used to indicate local colour on the cheeks, under the nostrils and on the lips. Notice the delicate and precise use of white chalk to highlight the form.

JAMES ABBOTT MCNEILL WHISTLER 1834–1903
Woman Seated 28 cm × 18·4 cm—11$\frac{1}{16}$ in. × 7$\frac{1}{4}$ in.
Black and white chalk on brown paper
Reproduced by courtesy of The Burrell Collection, Art Gallery, Glasgow

Whistler's sketch was also made in chalks on a toned ground but whereas Richmond was concerned with producing a meticulous and highly finished portrait, Whistler has produced a sketch, very slight but expressive and full of light. You can see by the different quality of the lines that he has used a softer crayon

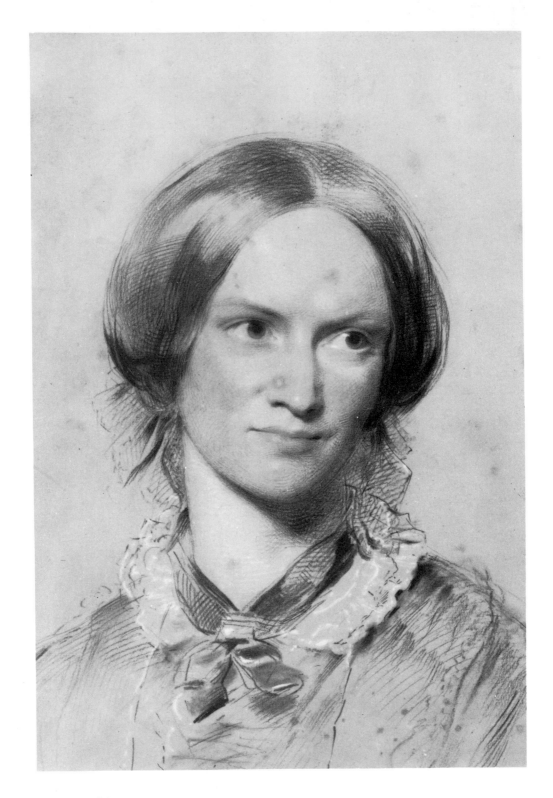

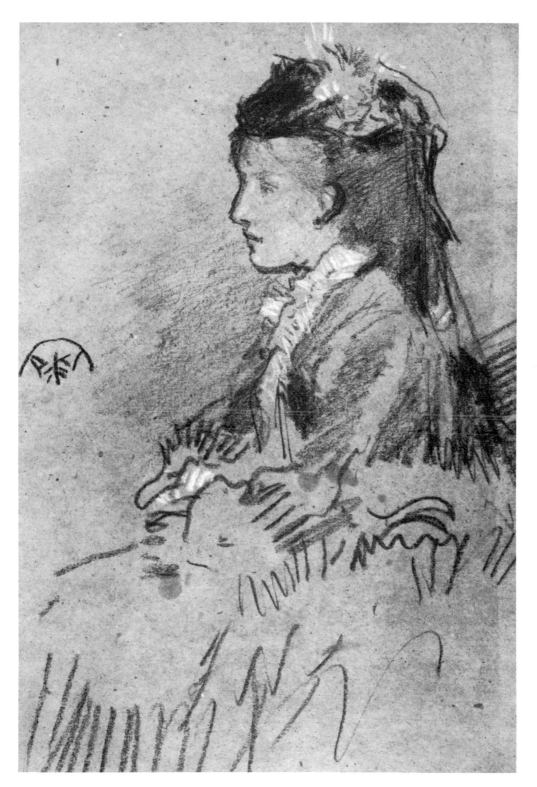

15

Emily 20·3 cm × 20·3 cm—8 in. × 8 in.
Black, red and white conté crayon on green/grey Ingres paper in three stages

I begin by sketching in the basic outlines with red conté—the advantage of starting with red is that (in this case) it is almost the same tone as the paper, so if I make any silly mistakes it is not going to show much. I try and get the proportions more or less correct, though I do not tie myself down too much at this stage—and I shade in the main tonal areas. I continue with brown conté, strengthening the tones and tightening up the drawing and move on to black when I am sure that everything is progressing as it should. You can see in stage 2 that I have put a bit too much black shading around the chin and mouth and I have to lighten it by working over with white to capture the subtleties of tone. The final stage consists in putting in white highlights and dark accents. The trick is to build up these darks and lights gradually without trying to rush things. Do not use too much white because it weakens the effect and makes the drawing look flat. You will notice I have left a fair amount of the paper uncovered on the forehead and cheeks—if you are working on a mid-tone you might as well use it and save yourself a bit of trouble. I recommend this use of different coloured chalks—the red and brown underdrawing adds a certain richness to the final result and also makes it warmer and more sympathetic—black and white by themselves look a little raw sometimes, especially with this kind of subject

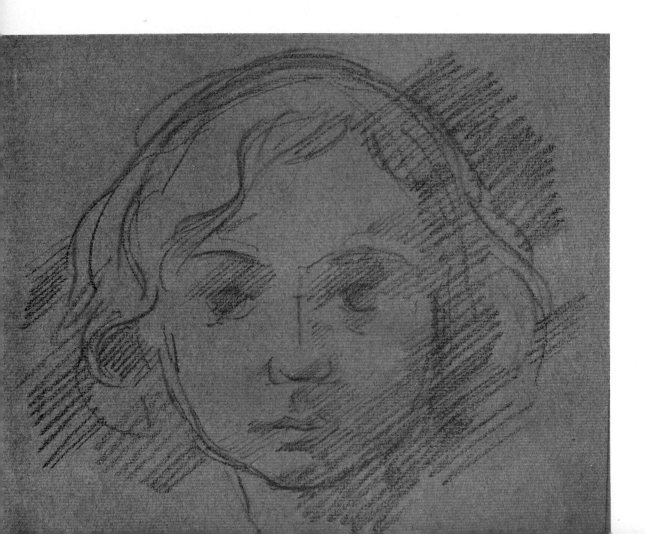

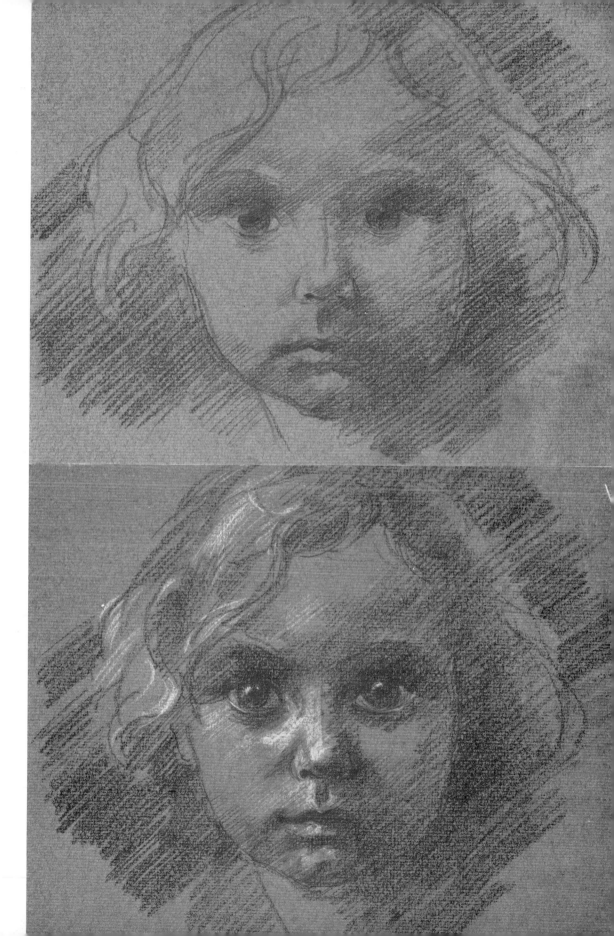

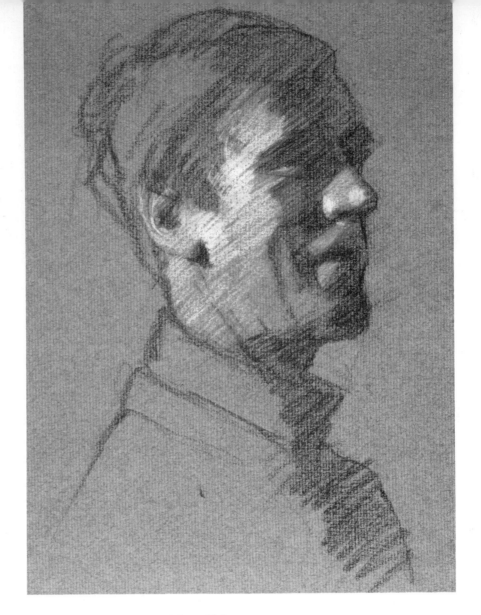

Igor 22·8 cm × 14·6 cm—9 in. × 5¾ in.
Brown and white conté crayon strengthened with a little black on green/grey
Ingres paper

This sketch was made from a snapshot I took on a sunny day. What chiefly
interested me was the pattern of light and deep shadow. When the areas of dark
and light are as sharply defined as this, it is easy to reduce the head to a series of
simple shapes. For instance, the portion of nose sticking out is easy to see as a
lumpy triangle, next to it on the left is another shape only darker, and after that
a lighter area, and so on. So remember to look for and put down the *shapes*, and
to make those shapes the right tone in the right place

PAUL HEDLEY
Reg 30 cm × 23·8 cm—12 in. × 9 in.
Red, brown and white chalk with touches of black on brown Ingres paper

18

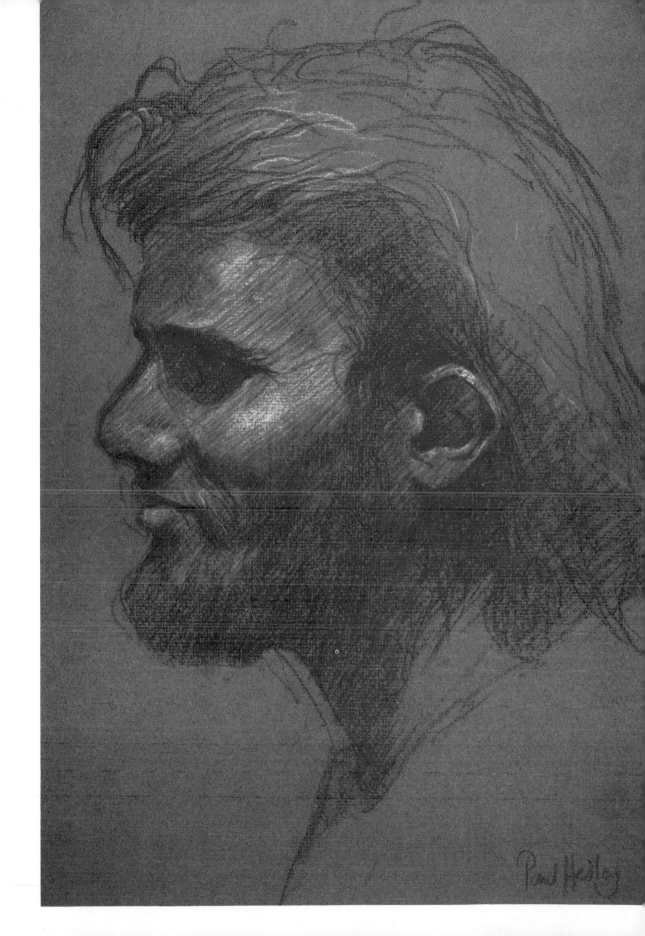
Paul Hedley

GEORGES SEURAT 1859–91
Self-Portrait 34·2 cm × 28 cm—13½ in. × 11 in.
Black chalk on white strongly grained paper
Reproduced by courtesy of Lénars, Paris

There is some doubt about whether this is a self-portrait because it closely
resembles Seurat's friend Paul Signac. Seurat used this technique in most of his
drawings. The specks of white paper showing through the tone give the drawing
a luminous quality which has much in common with his pointillist paintings. On
the following page I show how a similar effect may be achieved

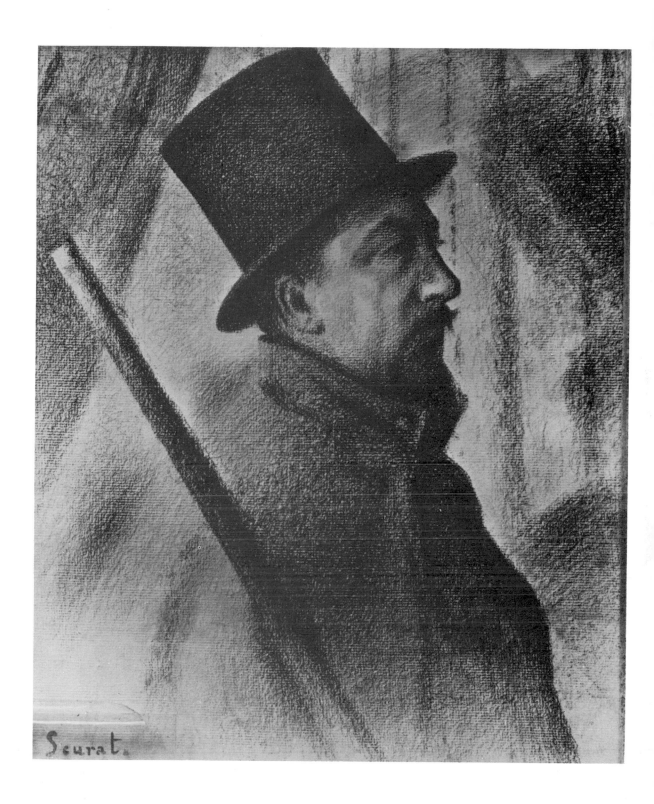

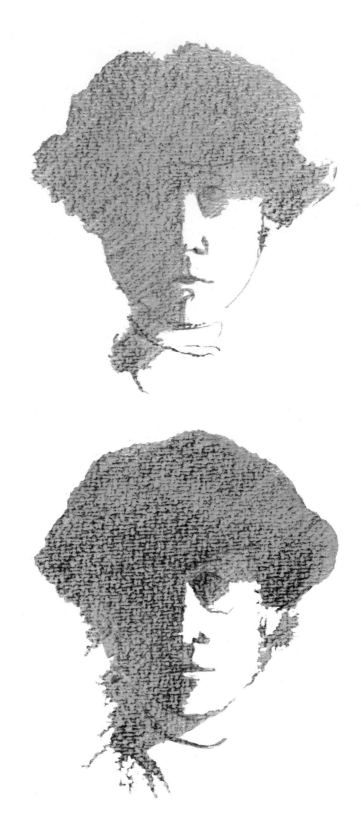

Shadowy Lady 7·6 cm × 6·3 cm–3 in. × 2½ in.
Black conté crayon on white Ingres paper

Stage 1 It is impossible to get this effect with smooth paper. This drawing is made in black conté on white Ingres paper. I begin with a very light drawing, merely indicating the main shapes. Since line itself plays little part in my aim, I try not to rely on it. I fill in all the shaded areas with a light even tone, holding the chalk so that it just brushes over the grain of paper. The tone at this stage is still so light that I can make any corrections I find to be necessary

Stage 2 I now start very gradually to build up the darker tones, applying more chalk in the same way. I try to look for the shapes of dark and light areas–it is a good way to stop yourself becoming too dependent on outlines. If you half close your eyes when looking at the subject, the details become blurred and the light and dark shapes can be seen in simplified shapes

Stage 3 Now I am sure everything is in the right place, I can add the darkest tones. It is important not to rush things–each layer of tone must be applied very lightly, rather like using a number of light watercolour washes to produce a dark one. If it is made too dark too soon, it is difficult to correct without spoiling the effect–if you try to rub it out, the shading gets smudgy and kills the sparkle of the paper showing through. The method is not unlike rubbing a coin except that you are minting it at the same time

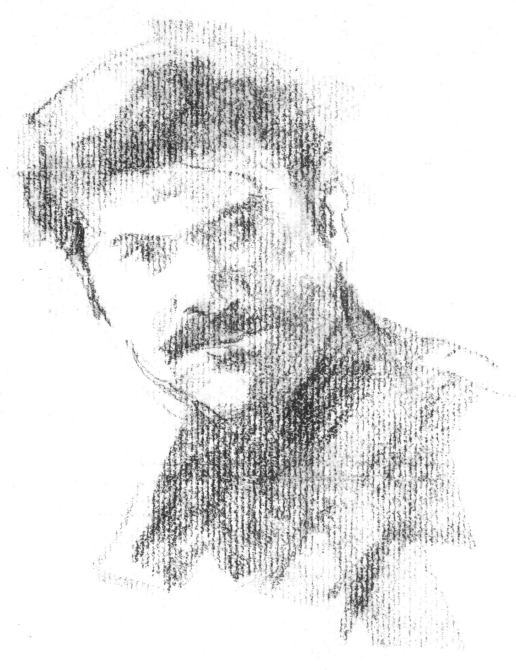

George 16·5 cm × 13·9 cm—6½ in. × 5½ in.
Red conté on white Ingres paper

This sketch was done in quite a different way. Instead of 'brushing' the tone on carefully, I put it on with the side of the crayon. As you can see I also used a certain amount of line. This direct technique is much more suited to working quickly

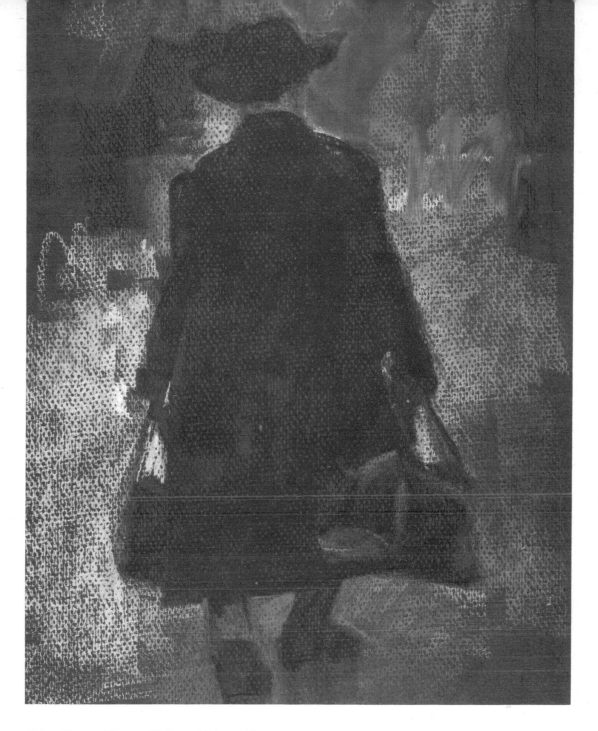

Going Home 30 cm × 17·7 cm—12 in. × 7 in.
Dark blue and white pastel on brown Mi Teintes Canson paper

This is not a portrait in the accepted sense, but you should avoid the obvious
poses once in a while. The way someone stands or moves is just as characteristic
as the way their features are arranged, and you can sometimes get just as good a
likeness with a back view. This sketch was roughed in with the side of pastel
(about 25 mm—1 in. long) on heavily grained paper

MARK GERTLER
Detail from *Golda* 21·5 cm × 19 cm—8½ in. × 7½ in.
Sanguine on white medium grain watercolour paper
Reproduced by courtesy of the Trustees of the Victoria and Albert Museum,
London

Here Gertler combines the technique Seurat used and his own rhythmical and expressive line. The swirling lines following the form of the head are continued round the neck and shoulders. He has rubbed in some of the tone with his finger on the top of the hair and cheeks. Some lights have been 'drawn' with a putty rubber, for example the reflected light on the right hand cheek and above the right hand eyebrow. The drawing has a convincing solid and sculptural feel to it See colour plate facing page 97.

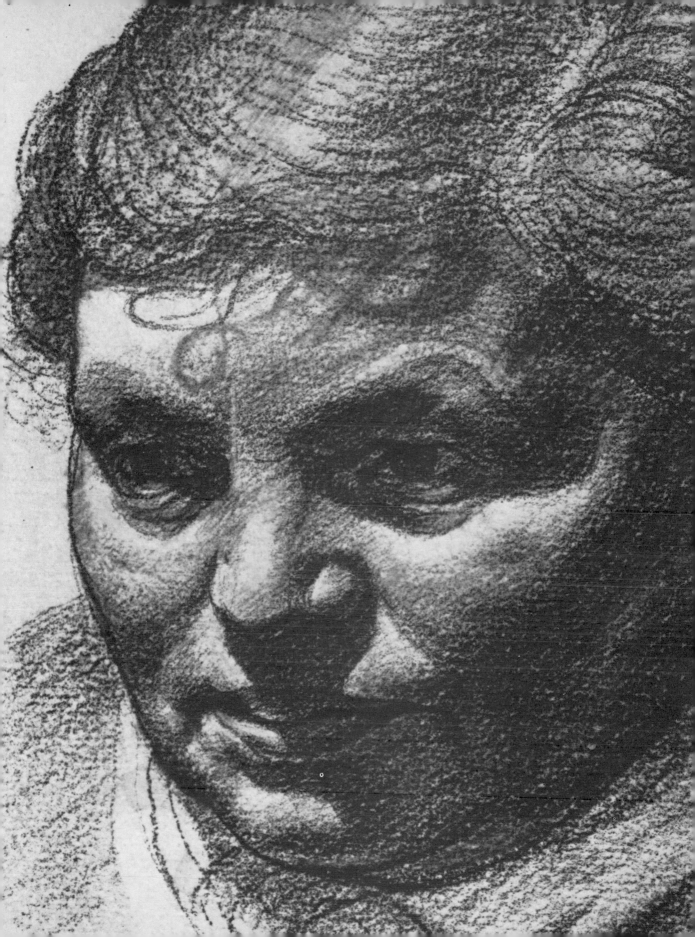

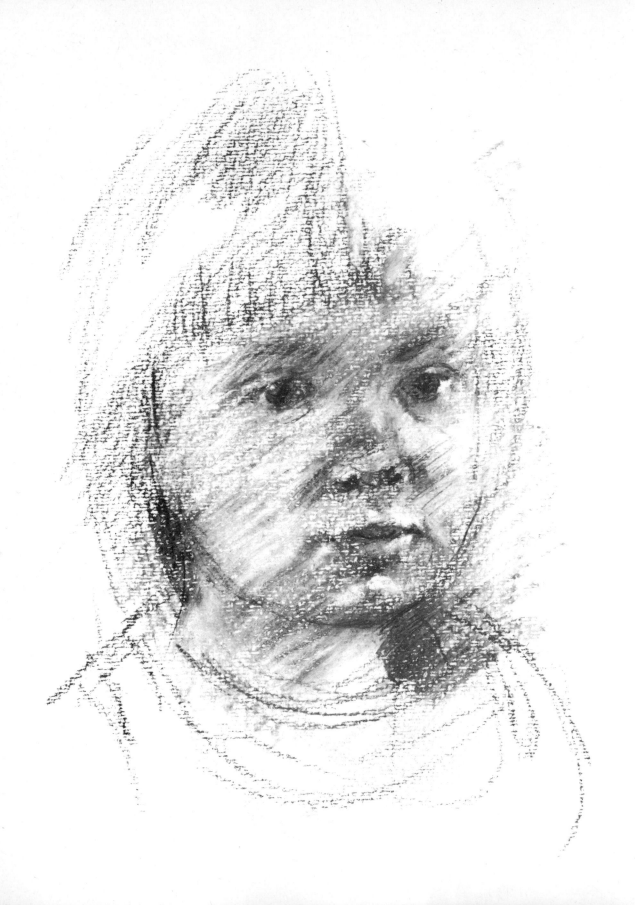

Roger 20·3 cm × 15·2 cm – 8 in. × 6 in.
Brown, red and white conté on white Ingres paper

I started this drawing in red and brown conté on Ingres paper, but it turned out to be rather inaccurate and I had to make a number of corrections. This made the drawing a bit confused so I worked over the messy bits with white to simplify matters. I ended up with a reasonable result although the white crayon was rather soft and caused a smeary effect which I do not like on the overworked parts

Nigel 16·5 cm × 16·5 cm – 6½ in. × 6½ in.
Black chalk, pencil and white chalk on white cartridge paper

Although I began this as a pencil sketch I later worked over it with black and white chalk

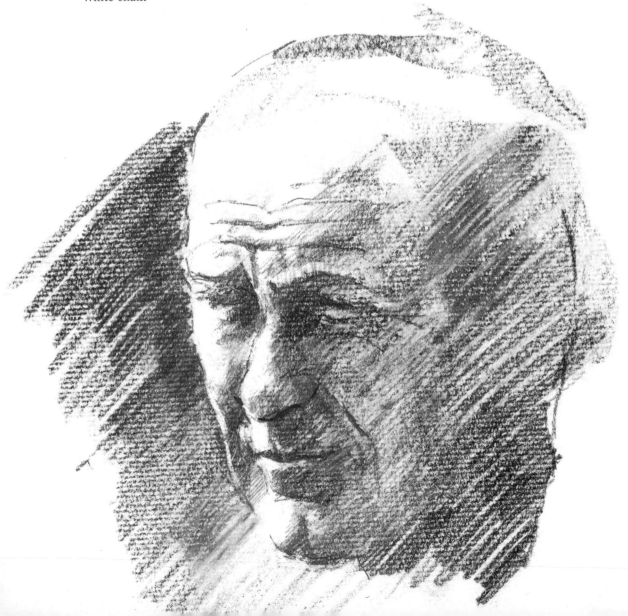

Jack 15·8 cm × 12 cm—6¼ in. × 4¾ in.
Black conté crayon on white cartridge paper

This illustration shows the use of cross-hatching. Again, the drawing is built up gradually from light to dark, one layer of shading superimposed on another. Line and tone were applied at the same time—try to avoid doing an outline drawing and 'filling it in'. Notice the use of a broken line, for instance down the left hand side of the face. This is more expressive than a continuous line of even thickness which tends to make the head look flat and mask-like

Myron 17·7 cm × 12·7 cm—7 in. × 5 in.
Black conté, burnt umber watercolour wash on white cartridge paper

I started the head with a few marks to establish the proportions then I applied a light wash of burnt umber watercolour. When this had dried I worked on top strengthening the darks. The soft floating sheen of watercolour in contrast to the grainy uncompromising marks of the black conté make an interesting combination

Winslow Homer 1836–1910
Child seated in Wicker Chair 33·6 cm × 25·4 cm–13¼ in. × 10 in.
Black crayon and white gouache with touches of pencil at arms of chair on light
grey paper
Reproduced by courtesy of the Sterling and Francine Clark Art Institute,
Williamstown, Massachusetts

When making a portrait it is a good idea to experiment with one or two props. In
this case Homer has used the wicker chair to make an interesting frame for the
model and her cat. Here white paint is used in the same way as white chalk, on
pages 14–19 so that we have three basic tones, black, white and the mid-ground

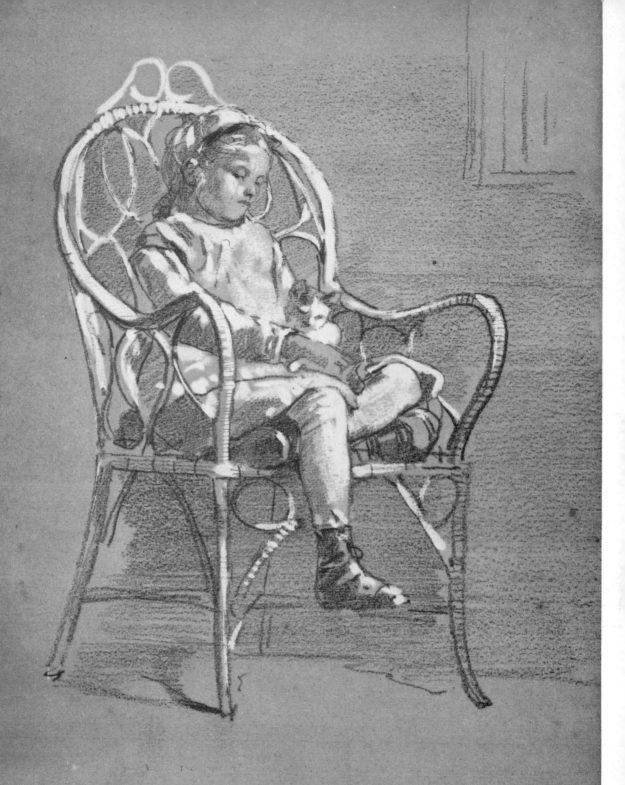

HOMER 1874

Man in Spectacles 15·8 cm × 13·9 cm—6¼ in. × 5½ in.
Black conté and wash on white Ingres paper

I did the basic drawing in black conté filling in the shadows fairly simply with diagonal shading. I worked over this with a wet brush to give a more even tone. When that had dried I added detail to the features with more drawing in conté. A wash of brown watercolour (burnt umber in this case) was brushed on to the background to throw up the light side of the head

Winston 15·2 cm × 10 cm—6 in. × 4 in.
Fountain pen/ink wash overlaid with black and white chalk and sepia water-colour on white cartridge

This sketch started out as a fountain pen drawing with wash, but as it was not going right I decided to work over parts in black and white chalk finishing off with a sepia wash over the shoulders. I have gone into more detail about fountain-pen ink on the section on ink and wash

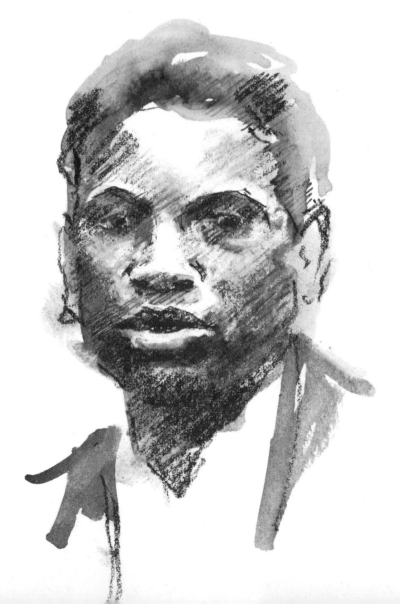

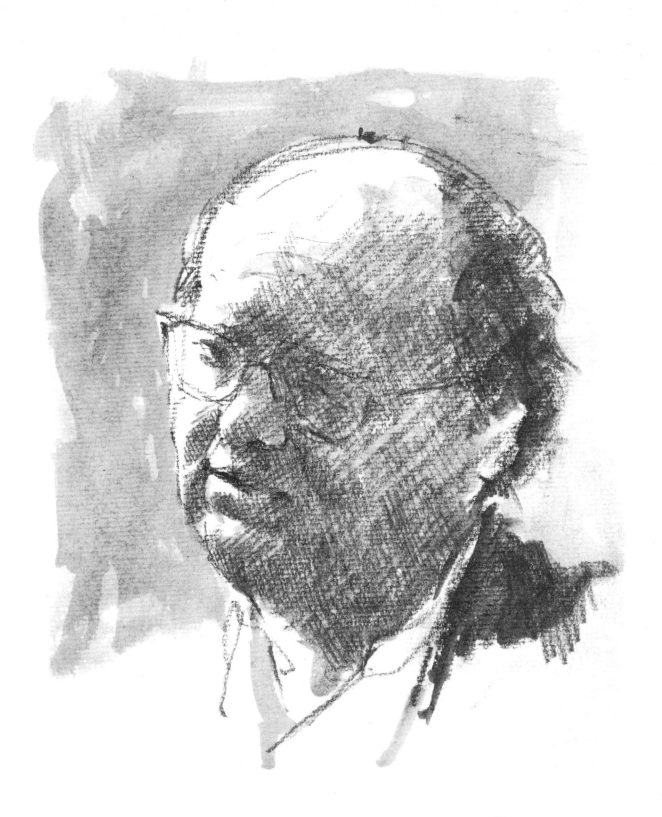

ADOLF VON MENZEL 1815–1905
Studies of an Old Man's Head (1866) 13 cm × 21 cm–5½ in. × 8½ in.
Black chalk and grey wash on light ground
Reproduced by courtesy of Kunstmuseum Düsseldorf. Graphische Sammlung.
Inv. no. 37/125

Menzel made many thousands of drawings and was one of the most prolific
artists of the nineteenth century. He was self taught. In his passion for drawing
he drew everything he could see besides producing watercolours, oil sketches
and paintings. He carefully stored all his sketches and studies for later use when
working on larger compositions and paintings. I do no not know for sure, but
it is likely that the wash was produced simply by brushing water on to the chalk
which tends to lift some of the particles to give a grey tone

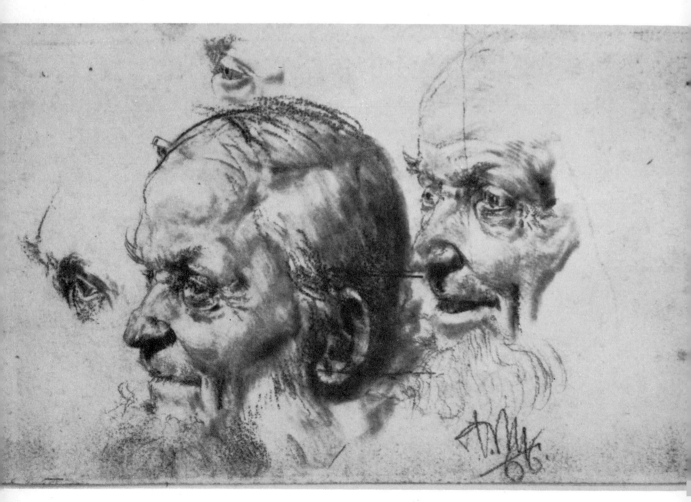

PETER PAUL RUBENS 1577–1640
Detail from *Study of the Head of a Young Lady* 24 cm × 20·3 cm—9½ in. × 8 in.
Black chalk on whitish paper heightened with white and red chalk reinforced
with ink wash
Reproduced by courtesy of the Trustees of the British Museum, London

This is an enchanting portrait; the whole effect is delicate and luminous. The
black chalk is drawn very lightly, reinforced with a light greyish brown wash on
parts of the hair, background and collar. The faintest pale pink tone (which
looks like a combination of red and white chalk) has been lightly rubbed across
the cheeks and mouth. White highlights are visible on the nose, brow, and round
the eyes. White has also been worked over the dark shading on the right hand
side of the head See colour plate facing page 73

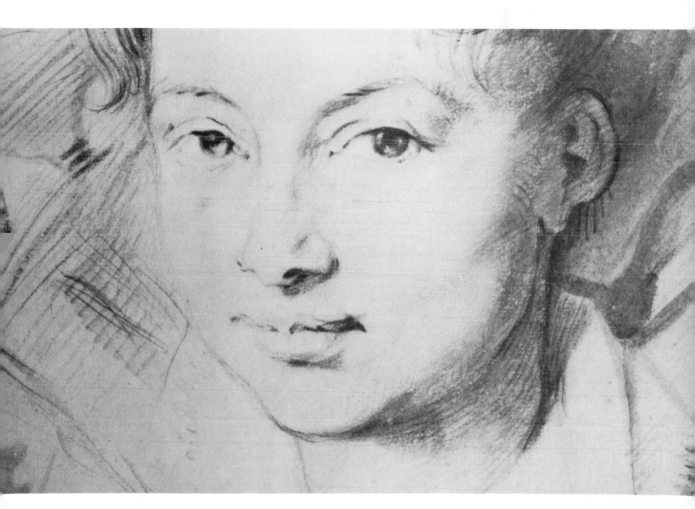

Charcoal

Charcoal is one of the oldest drawing substances still in use. It is a gentle and flexible medium and can give velvety darks as well as the palest areas of tone. It can be used in a precise, highly finished way, or freely and spontaneously. Many Master works have an under-drawing in charcoal with subsequent marks overlaid in black chalk or pen and ink, or a combination of all three.

A wet brush washed over charcoal gives an area of tone as well as retaining the freshness of the charcoal line. The water also acts as a mild fixative. If you find that charcoal smudges too much, you can remedy this to some extent by drawing in stages, fixing each stage before moving on to the next.

Charcoal can be used on any kind of paper, but it is not very happy on a smooth surface. Good quality lining paper from the decorators' shop is useful. Much of what I have said in the section on chalks about paper and putty rubber applies equally well to charcoal.

GUSTAVE COURBET 1819–77
Self-portrait 27 cm × 20 cm—$10\frac{11}{16}$ in. × 8 in.
Charcoal on light ground
Reproduced by courtesy of the Wadsworth Atheneum, Hartford, Connecticut

Look closely at the way this portrait has been composed. It creates a casual but rather cunning composition. The brim of the hat, the angle of the pipe stem and the various collars have been deliberately posed to great effect. Much of the tone seems to have been put on by using the charcoal stick on its side. From the angle at which Courbet has painted himself I suspect that the mirror was tilted so that we have the feeling he is looking down on us. Once again, it is worth considering how this picture might have looked with a different value in the background. The atmosphere looks to me rather murky and mysterious. Notice that all the interest is centred on the top half of the face. To enhance this Courbet has understated the tonal value on the hat, allowing it to merge into the background. It is as well to be aware of the emphasis you want so that areas which are not particularly important do not start jumping forward for attention

40

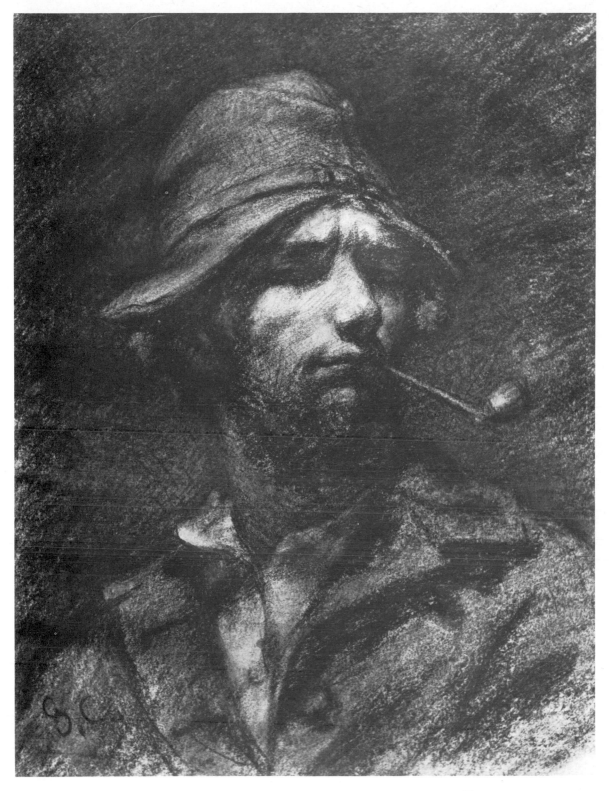

KAETHE KOLLWITZ 1867–1946
Self Portrait 47·6 cm × 63·5 cm—18¾ in. × 25 in.
Charcoal on white ground
Reproduced by courtesy of the National Gallery of Art, Washington D.C.,
Rosenwald Collection

This is a favourite drawing of mine mainly because of the arresting and unusual
composition. The dark head against the light ground looks as though overall
tone was applied first, probably with the charcoal on its side, then worked into
with the tip of the stick, to give darker accents. The texture of the paper shows
through clearly. It also shows that a self-portrait need not necessarily be full face
or threequarters, this profile would be achieved with two mirrors. Notice the
rich variety of marks in this portrait, for instance the vigorous zigzag tone along
the arm and the taut fine lines over the top of the skull. If you experiment holding
the charcoal stick in various ways, you will discover that all these marks can be
made from the same piece

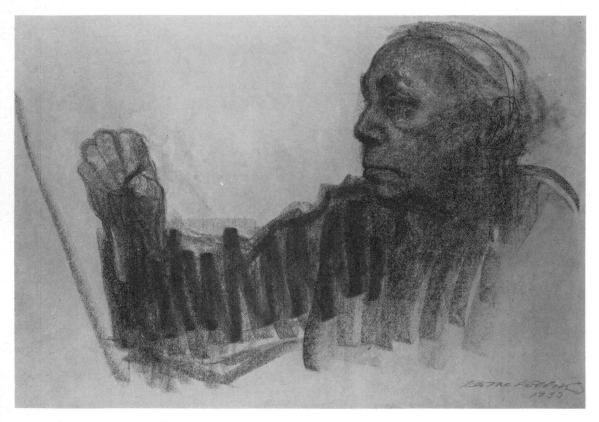

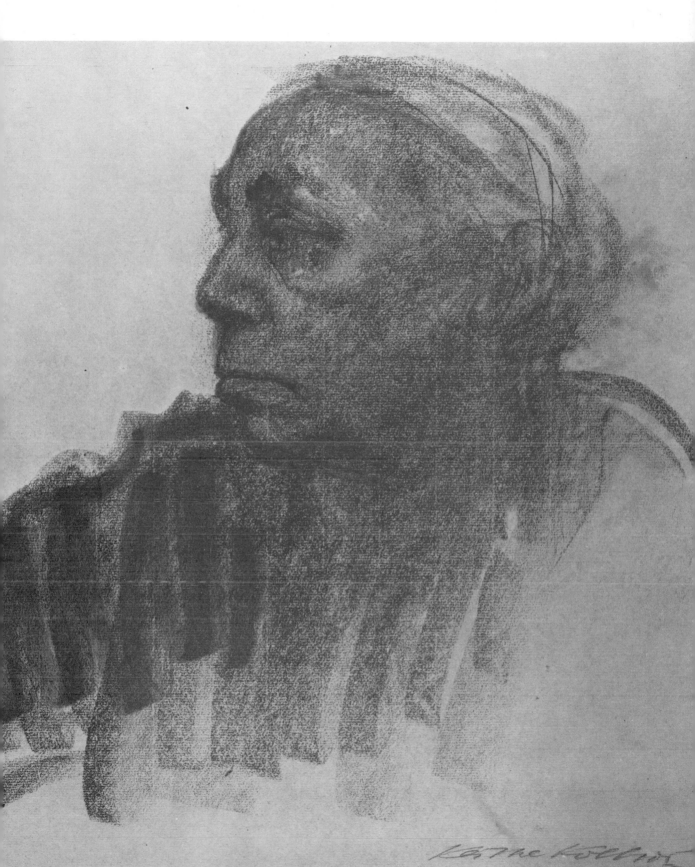

Profile in Shadow: in 3 stages 20·9 cm × 17 cm—$8\frac{1}{4}$ in. × $6\frac{3}{4}$ in.
Charcoal on white Ingres paper

Stages 1, 2 and 3
I began with a simple line drawing, not too heavy because I was most interested
in the shape and tones of the head against the light and the nuances of shadow
and reflected light within it. I applied the tone by 'brushing' it on gently (with
the side of the charcoal) to make it fairly even, allowing the texture of the paper
to come through – building up darker areas with more such shading. The advan-
tage of charcoal is that if the tone becomes too dark you can easily lighten it by
lifting off the charcoal dust with a fingertip or a dry brush. I found that as the
drawing progressed I could not get the effect of light on the hair to my satis-
faction, so I did it by 'drawing' into the tone with a putty rubber, though (like
smudging with the finger) it does not pay to overdo it. Too much smudging and
the surface of the paper becomes disturbed and the luminous tone ends up being
dirty and dead

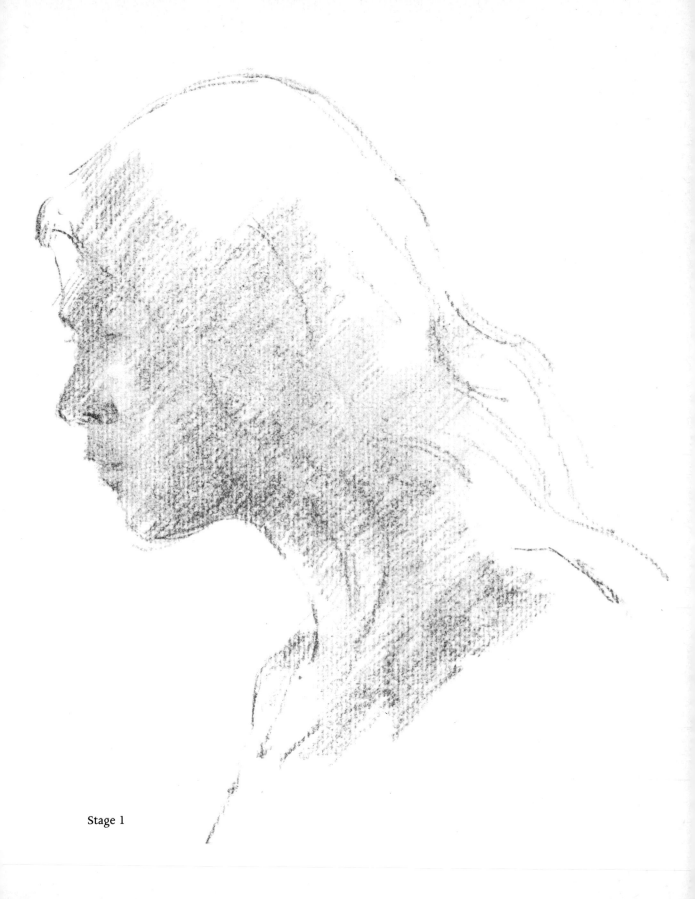

Stage 1

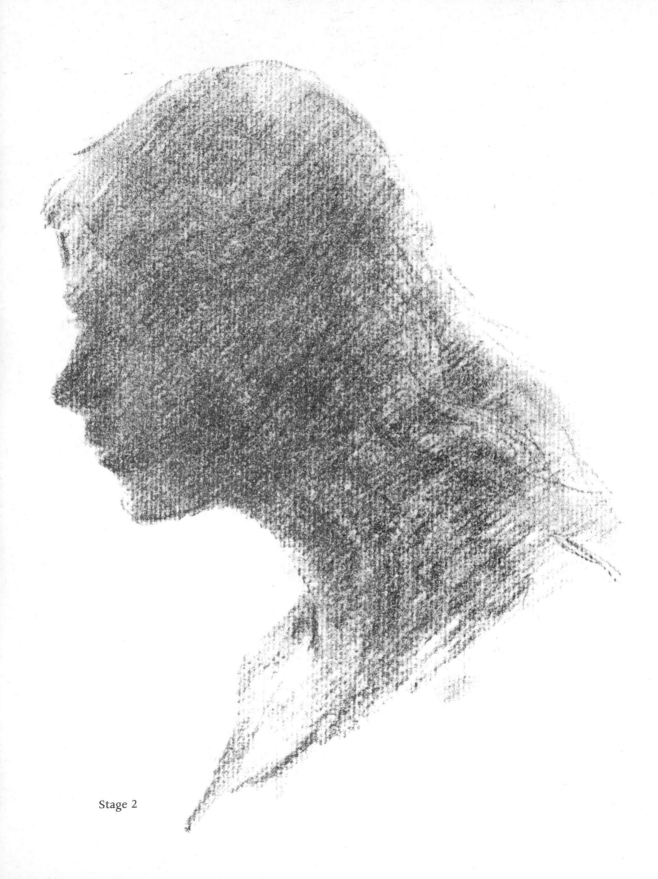

Stage 2

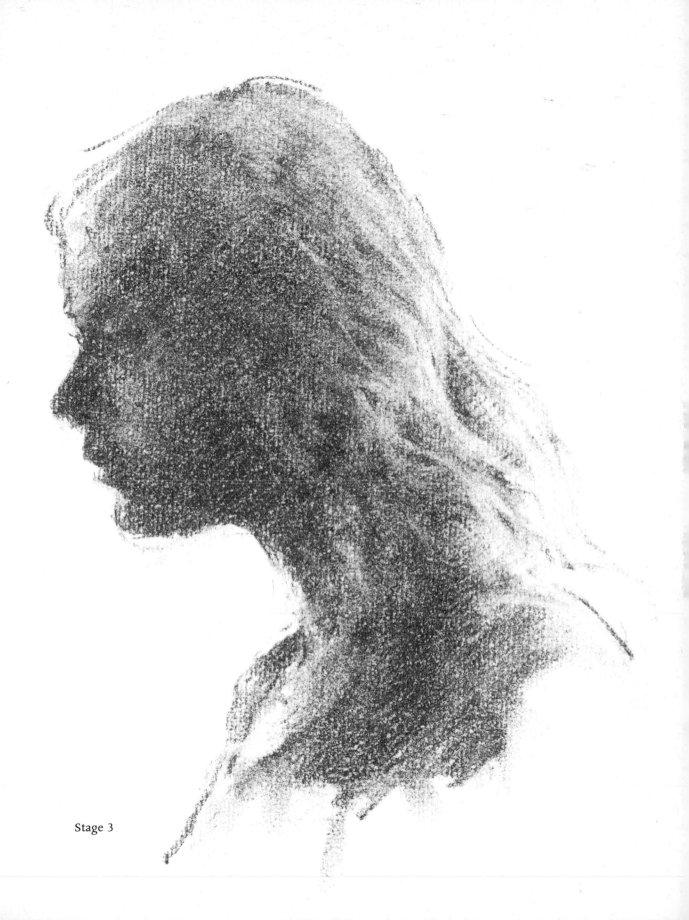

Stage 3

MAX LIEBERMANN 1847–1935
Two studies for a portrait of Justus Brinkmann 26 cm × 29·8 cm—10¼ in. × 11¾ in.
Reproduced by courtesy of the Kunsthalle, Hamburg

These two drawings show part of the process of working out the composition for
a portrait. In the first one below you can see the artist struggling a bit, correcting
and redrawing. It is the work of a man who hasn't warmed up yet and hasn't
decided exactly what he is going to do. The second illustration (opposite) is much
more assured: the pose is only slightly different, but the sitter looks more relaxed
and natural, and the vertical left leg gives greater stability to the composition.
The artist looks more relaxed too – his line is more fluent and decisive now that
he has got to know his subject and has found the most suitable pose

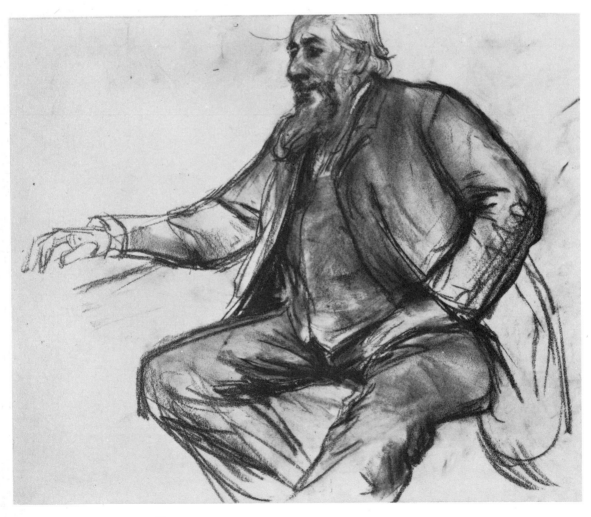

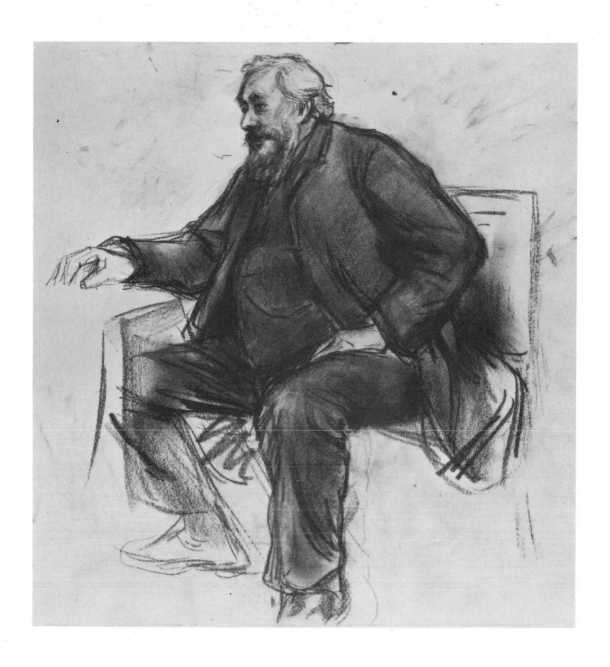

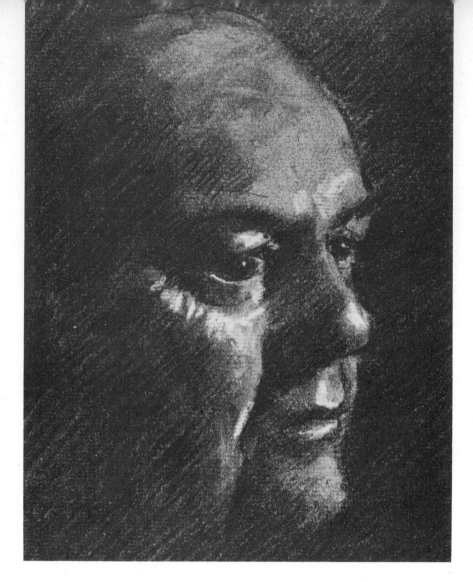

Luigi 22·8 cm × 16·5 cm—9 in. × 6½ in.
Charcoal on white Ingres paper

This drawing became a struggle and is very heavily worked. I had to make quite a number of corrections before I was satisfied and used the putty rubber to get some of my lights back. The paper was grey by the time I had finished and I had to add some touches of white chalk to the highlights to give the drawing a bit of sparkle. Charcoal can do wonderful things, it can also run away with you, so experiment as much as possible just to find out the feel of it and which papers and textures suit your particular purposes best

Gay 22 cm × 16 cm—9 in. × 6½ in.
Charcoal on cartridge

The rather heavy jagged hatching which I emphasised allows streaks of light to show through and to some extent it helps the feeling of movement which I wanted to achieve

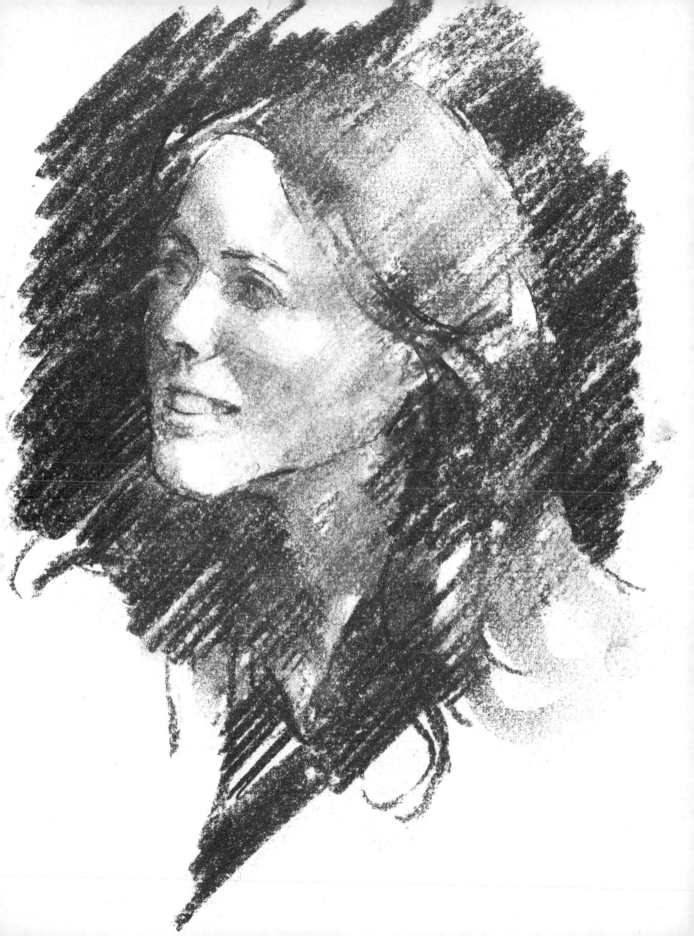

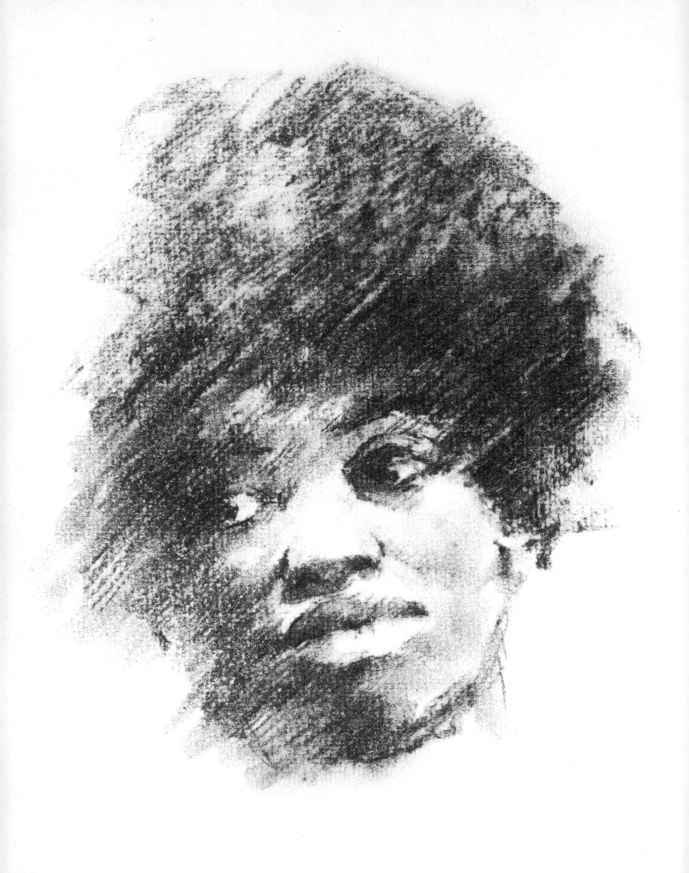

Sonia 17·7 cm × 15·2 cm—7 in. × 6 in.
Charcoal on white Ingres paper

This uses the same technique as for *Gay* on page 51 but the textured Ingres paper holds the charcoal rather better. This drawing is in fact inaccurate in that the model's right eye is sloping away from the socket but I have included it because although I think it is important to start off by trying to be accurate, this does not mean that accuracy is everything. Had I started another drawing I doubt whether I would have caught the characteristic wistfulness of the sitter

JEAN FRANÇOIS MILLET 1814–75
Head of a Young Girl 47·6 cm × 31·7 cm—18¾ in. × 12½ in.
Charcoal on light ground
Reproduced by courtesy of The Burrell Collection, Glasgow Art Gallery

I really enjoy looking at this drawing. But, as I said at the beginning of the book, we want to do more than enjoy, we want to learn from a picture. We can see that Millet has lit his subject in such a way that the light turning into the shadow of the right side of the face occurs at exactly the right spot. Can you imagine how different in mood and feeling this picture would be if the entire face was in light, or even lit from below. He has got it just right, and the area of light on the neck echoes the light on the face so that a deep velvety band of shadow crosses the chin and throat. When you start on a portrait this question of exactly where the light falls is one of the most important things to consider

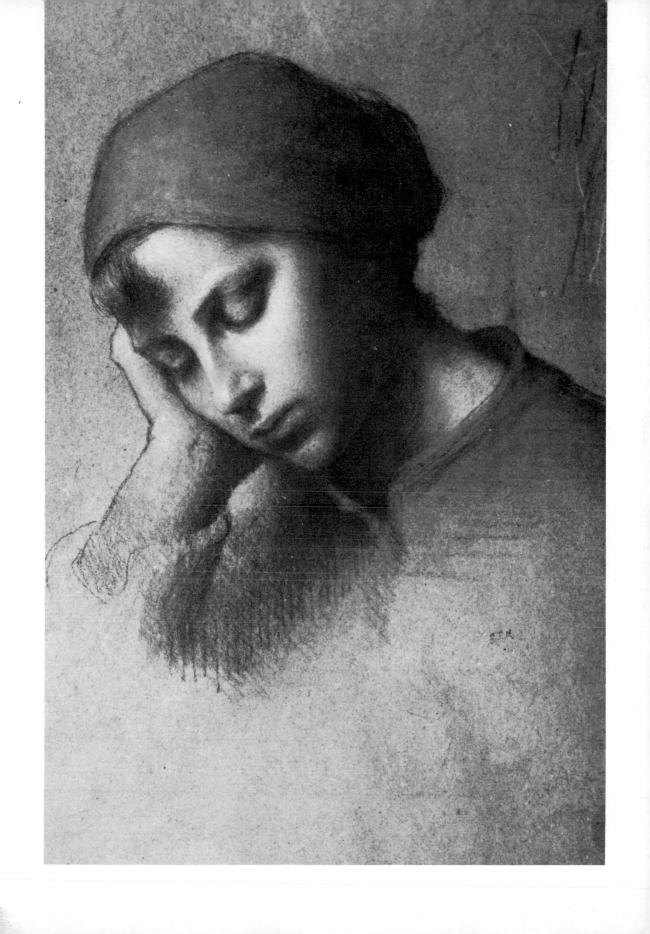

Eileen 17·7 cm × 12·7 cm—7 in. × 5 in.
Charcoal and white chalk on green/grey Ingres paper

Linda 20·2 cm × 13·9 cm—8 in. × 5½ in.
Charcoal and white chalk on Ingres paper

Here are two exercises in light. It is refreshing to make light work as a line (as in the case of Eileen's hair) and it is worth experimenting with light chalks on black paper. I have used the white chalk and charcoal to model her features but again I have left the paper to form the background and the tone of the right side of the face.

Linda was sitting in front of a window and I have put in the light background with white conté allowing the grey/green of the paper to provide the overall tone of the figure. There is some shading in the hair and clothes, but very little on the face although I used a few highlights to give it solidity

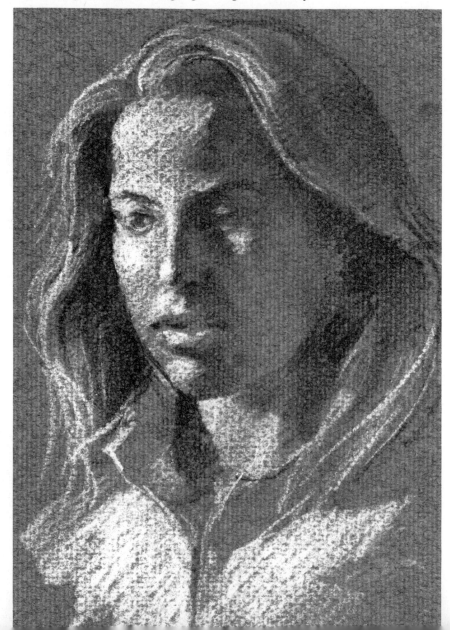

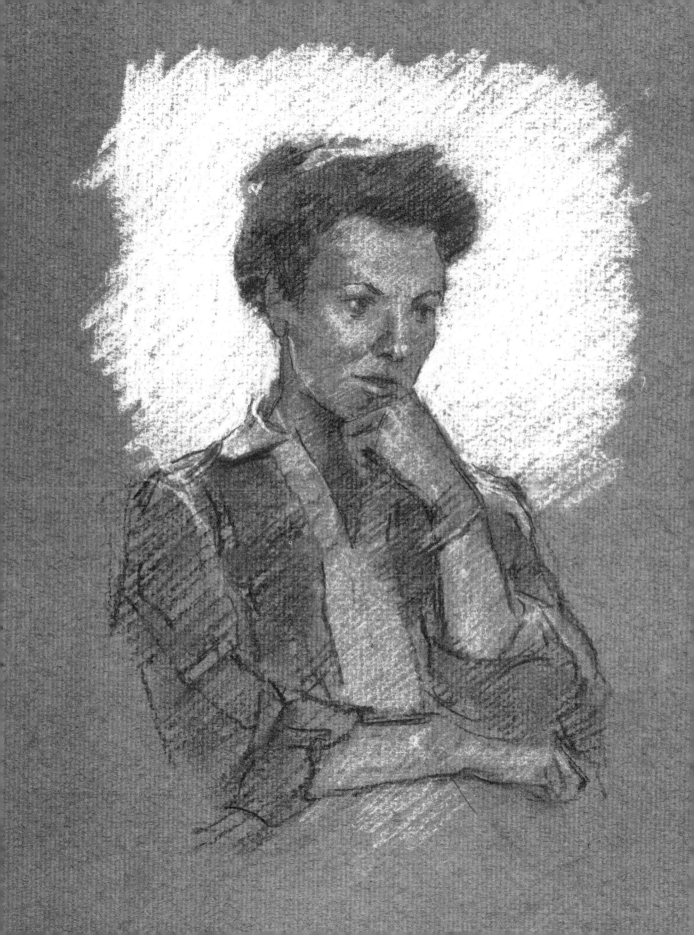

Beryl 30·4 cm × 30·4 cm—12 in. × 12 in.
Charcoal and white chalk on grey Ingres paper

Charcoal lends itself to free-flowing, flamboyant lines but I feel that this portrait is a little too flamboyant. The hard dark tones round the edge of the face give a mask-like appearance. It is a good idea to work on a large scale in charcoal. Draw standing up so that you can get the full swing of your arm right from the shoulder. The chances are that if you always work sitting down, your drawing strokes will be made from the wrist, which gives a very different effect

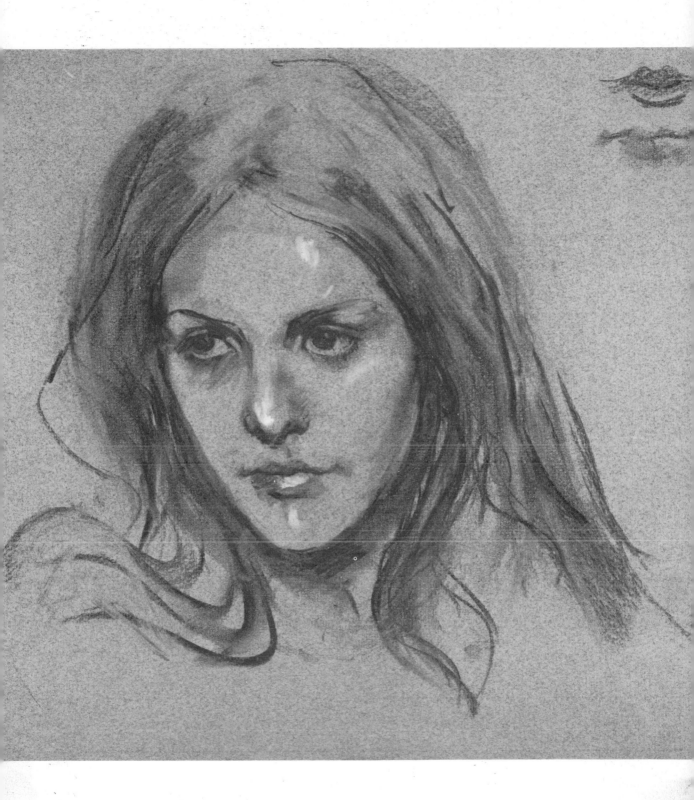

ALBRECHT DÜRER 1471–1528
Portrait of a Girl 42·7 cm × 29·3 cm–16$\frac{13}{16}$ in. × 11$\frac{9}{16}$ in.
Charcoal on light ground
Reproduced by courtesy of Kupferstichkabinett, Staaliche Museen Preussischer
Kulturbesitz, Berlin (West)

There is a tremendous variety of line in this picture. The changes in plane on the
face are shown by areas of soft tone, probably rubbed in with the finger. The
texture of hair and clothes is expressed by much heavier lines, rather sketchily
drawn, which emphasises the face, drawn with great subtlety and sensitivity.
Considering it is over 450 years old, the portrait has a delightful freshness and
immediacy

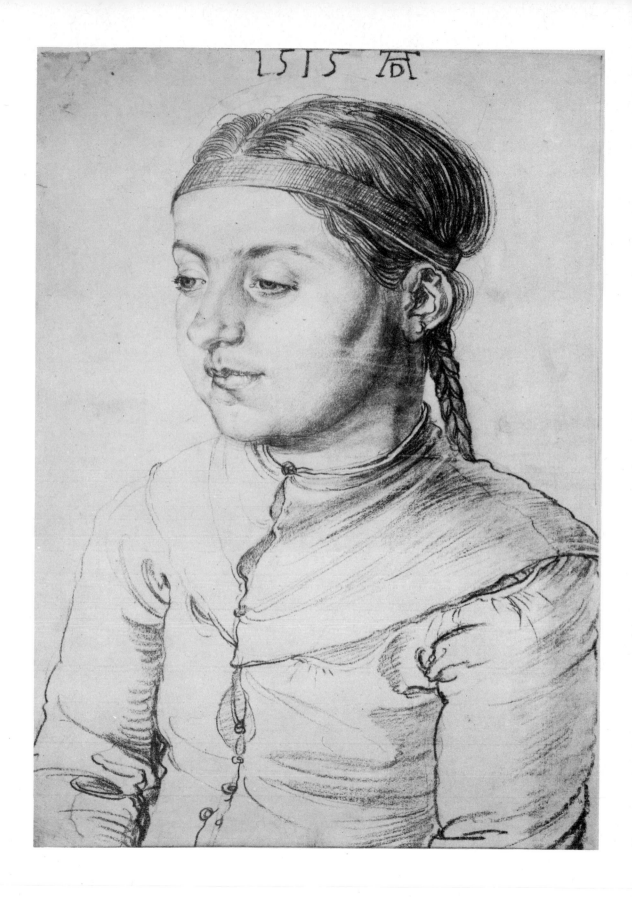

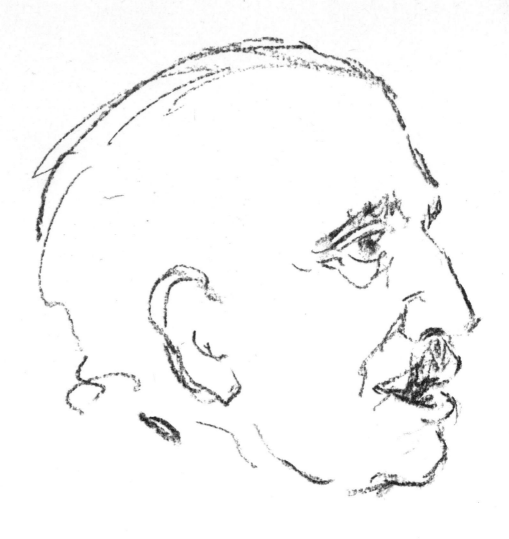

Man in a Crowd 11·4 cm × 9·5 cm—4½ in. × 3¾ in.
Charcoal on white cartridge

A brief sketch relying on the lively quality of the charcoal line

Pamela 15·2 cm × 8·2 cm—6 in. × 3¼ in.
Charcoal and wash on white cartridge

Another charcoal sketch with a final wash of water brushed over with a sable
brush

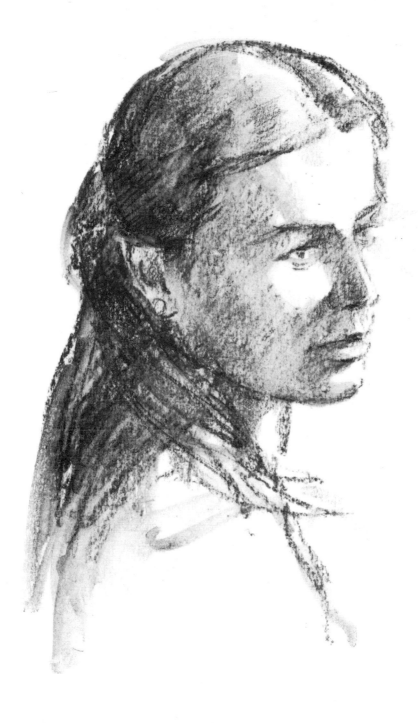

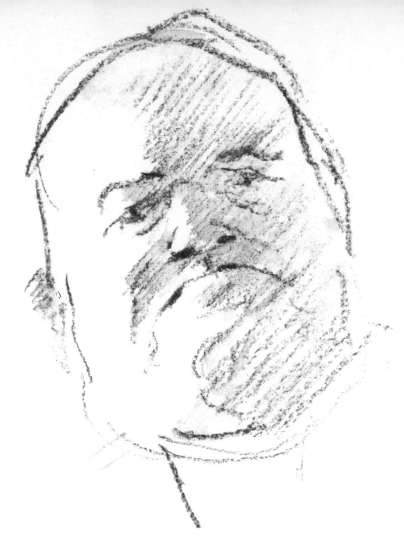

Humpty Dumpty 14·6 cm × 9·5 cm—5¾ in. × 3¾ in.
Charcoal and wash on white cartridge

Here I have deliberately kept the tone to a minimum. I began by a slight indication of the top of the head, as this was what originally caught my interest, then I worked across the eye sockets, placing the nostrils then the mouth. I next restated the sides and general width across the ears. Because the light coming from the left was so pronounced, I lightly hatched the cast shadow down the length of the head. Finally, I dipped a brush in water and washed over this shaded area

Donald 15·2 cm × 15·2 cm—6 in. × 6 in.
Charcoal and wash on cartridge paper

The strong light from the left was the chief interest in this drawing. Above all else I wanted to keep the light areas simple and uncluttered. The dark area behind the left shoulder emphasises the light. Details in shadow should always be much less definite and distinct than details in light. Because the charcoal was dense in the shadows I dipped my brush in water and dragged it across these dark areas. As it dried it produced an interesting blotchy effect

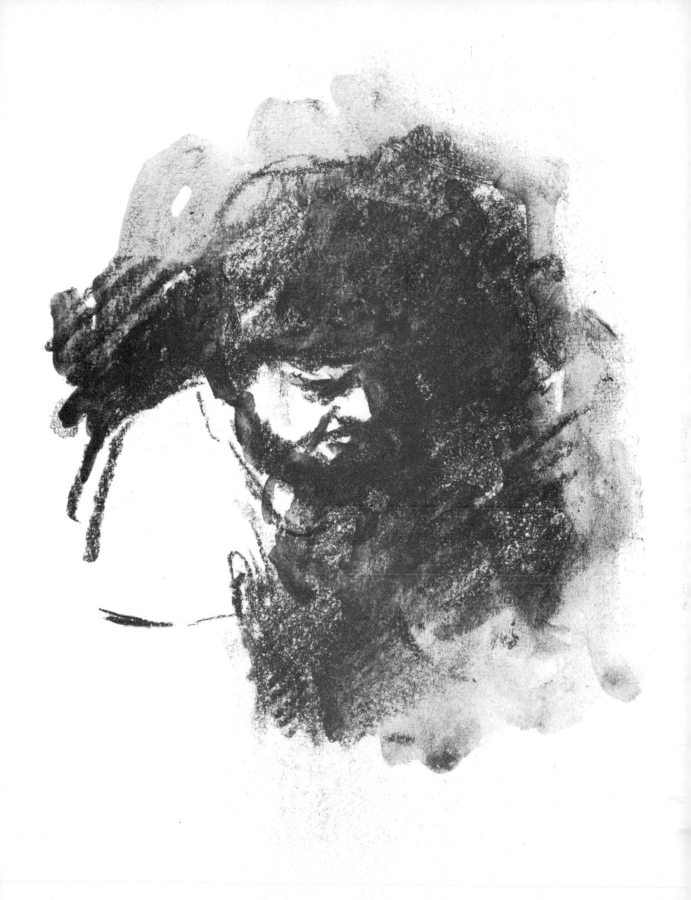

Pencil

When you mention 'drawing', the chances are that the first thing a person will think of is pencil. The pencil's chief advantage is its convenience. For this reason it is invaluable for sketchbook drawings, but in general I prefer not to use it. It seems to have a kind of inhibiting effect on my drawing, and I know other artists who say the same thing. I do not know why that should be, but I am convinced that it is a difficult tool to use well. Given the choice, I prefer to use almost anything else except, as I say, for quick sketches when it really comes into its own. I have no wish to foist my prejudices on to anyone, but I am sure it is important not to get into the habit of using pencil exclusively. I would rather see a bad drawing in charcoal or pen and wash than one in pencil – at least it stands a chance of being more lively and interesting.

The 'lead' of a pencil is graphite and comes in various degrees of hardness from 4H the hardest to 6B the softest. Bs are soft Hs are hard increasing with numbers. I prefer to use the middle of the range HB, B and 2B. Softer pencils I find rather annoying because they become blunt so quickly. Harder pencils are rather scratchy and produce a very grey tone. I find a B or 2B pencil gives me all the tonal range I need, from lightest greys to good rich darks. Many people like to use a soft pencil and rub in the shading with their fingers. I do not want to lay down any laws, but I strongly advise against this practice – it produces a superficially attractive effect, but tends to weaken the drawing and makes for a flat, dead tone. Also you do not have so much control (after all a blunt finger end is not a precise drawing instrument) and you cannot achieve the subtleties of tonal changes that are possible with cross hatching. Having said that you might like to notice the finger rubbing in the Rubens drawing and the Henry Moore – but they were not using pencil Remember that pencil drawings need to be fixed especially when they are in sketch books.

Paper
Do not use very soft paper like sugar paper or newsprint – especially if you are using a hardish pencil, which tends to dig in and make unpleasant ruts instead of moving easily across the paper. I do not think pencil looks very well on toned paper, unless you are using it in conjunction with another medium – generally it is best to stick with white. I would advise too against drawing on a very rough surface which makes for hard work and a nasty fuzzy effect.

Rubbing out
One of the reasons pencil is so popular and so widely used is that it can be rubbed out – a great attraction for those who are not very sure of themselves. If you are short of paper or the shopping list needs altering, all well and good, but when you are drawing I would encourage anyone to use the eraser as little as possible. Of course, you cannot do a drawing without making mistakes, neither can you learn from those mistakes if you obliterate all evidence of them. If you decide a line is wrong do not rub it out. It is much easier to make a correction whilst you can see the offending mark. Use your rubber only as a last resort – when the tangle of lines gets so confusing you cannot see what you are doing. Make sure you use only very light marks in the early stages and introduce darker and heavier lines only when you are sure of your ground. The sum of various mistakes and corrections is likely to be a more interesting drawing than a neat, tarted-up effect.

Overleaf
Augustus Edwin John 1878–1961
Caspar 29·8 cm × 14·6 cm—11¾ in. × 5¾ in.
Pencil on white ground
Reproduced by courtesy of the Courtauld Institute of Art

Woman with the crazy eyes 22 cm × 17·7 cm—8⅝ in. × 7 in.
Hard black pencil on white paper
Reproduced by courtesy of the Isabella Stewart Gardner Museum, Boston, Massachusetts

These two drawings illustrate different aspects of pencil technique. *Caspar* is a quick sketch done in soft pencil, almost entirely in line. It captures beautifully and economically a momentary attitude. The drawing of Miss Schepeler could not be more different in approach but in its way is just as skilful. It was done with a hard pencil as can be seen from the quality of the line. It is a much more calculated piece of work, but the use of shading is marvellously delicate and exact

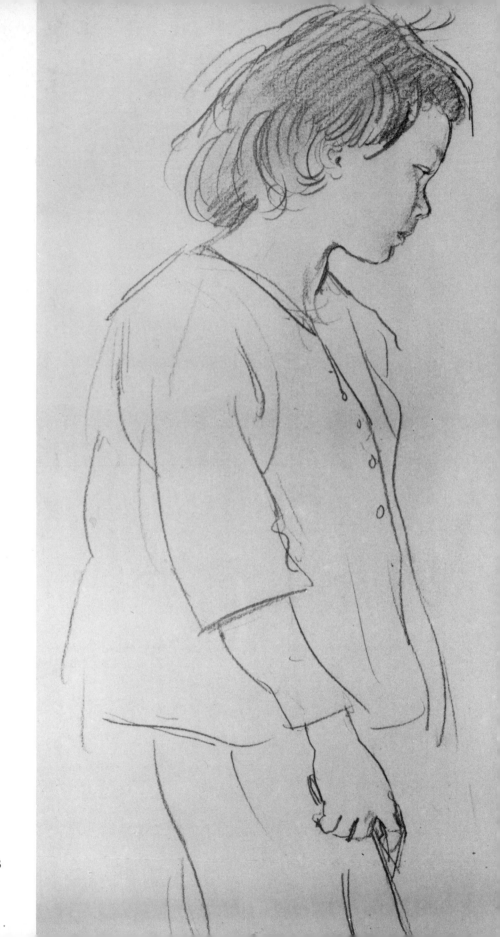

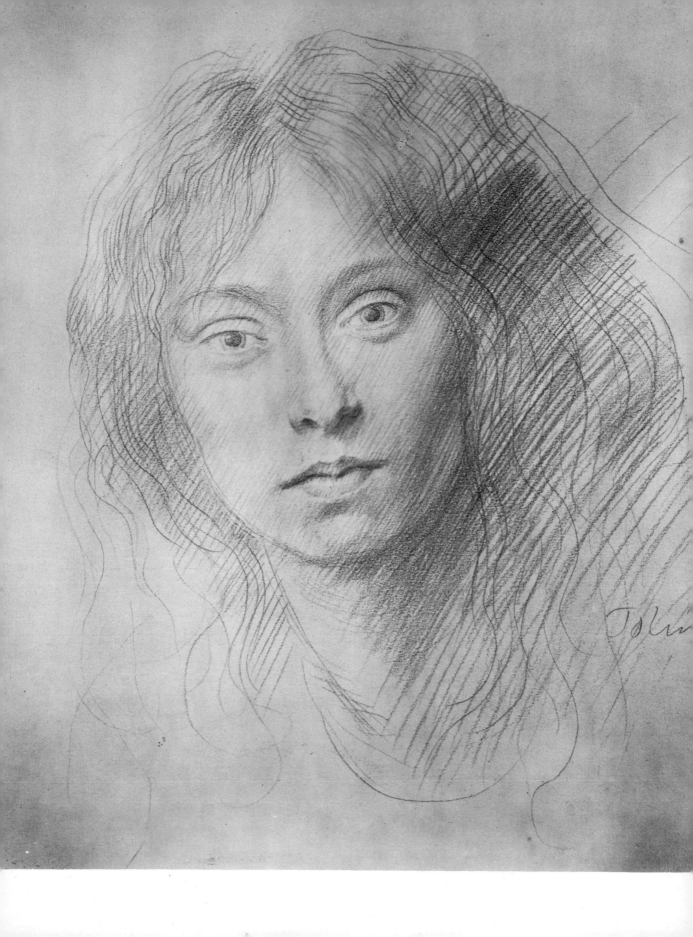

Ted 13·9 cm × 6·3 cm—5½ in. × 2½ in.
2B pencil on white cartridge

A sketch using simple masses of tone to give the feeling of strong sunlight

Sheila 14·6 cm × 12 cm—5¾ in. × 4¾ in.
HB pencil on white cartridge

In *Sheila* on the other hand, I used an HB pencil. It was done in artificial light,
the shading applied in a much more controlled way to try and capture subtleties
of tone. It seems to me to be rather dull and mannered in comparison with *Ted*

Profile 14·6 cm × 12 cm—5¾ in. × 4¾ in.
HB pencil on white cartridge paper

ANTOINE WATTEAU 1684–1721
Studies of Heads 33 cm × 23·8 cm—11 in. × 9⅜ in.
Red, brown and white chalk on light fawn paper
Reproduced by courtesy of The Trustees of the British Museum, London

These drawings which delight us with their apparent simplicity and grace were doubtless regarded by Watteau as studies for future reference rather than finished works. The lighter toned chalk would probably be applied first followed by the darker, with the white highlights last of all. If you look at the hair (above the ear) on the bottom right hand study, you can see another faintly drawn face. This may give some idea how Watteau started to construct a head

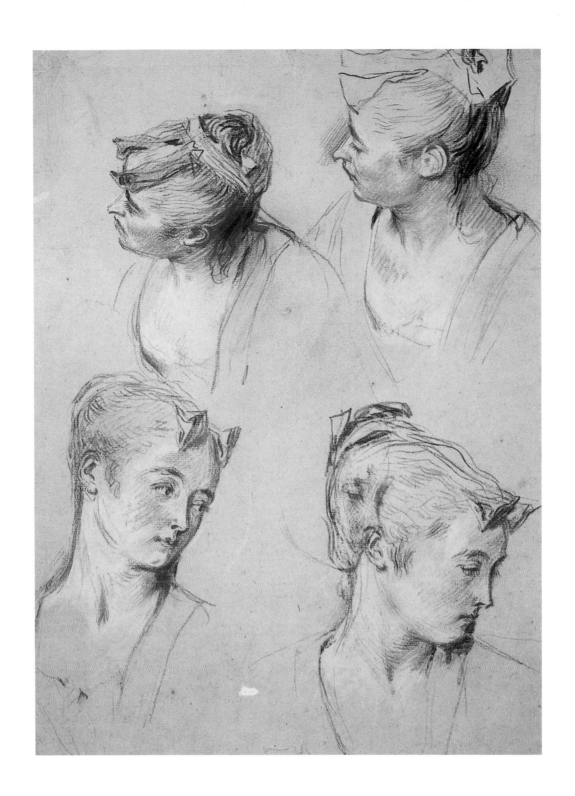

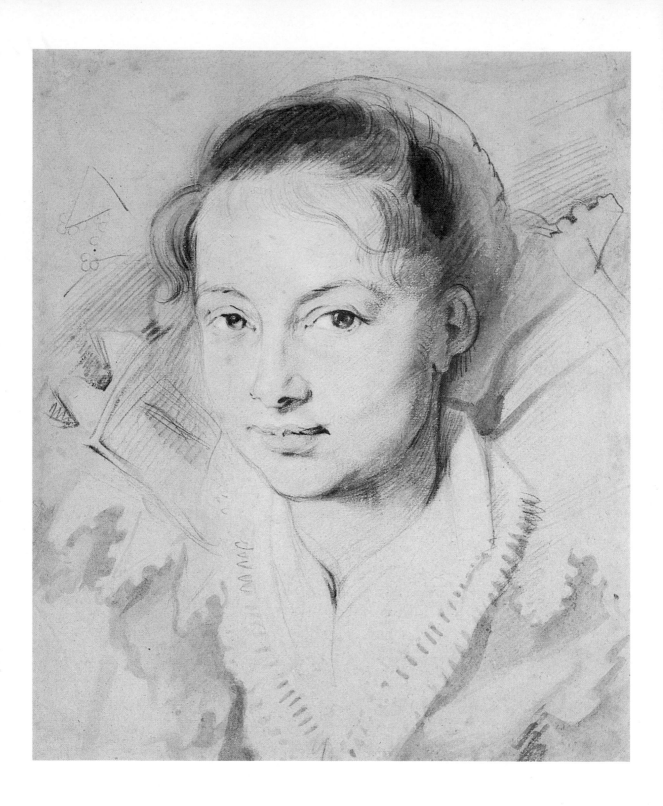

Girl in Scarf 10 cm × 8·8 cm—4¼ in. × 3½ in.
HB pencil on white cartridge

The striking profile on page 72 was drawn from a photograph which caught my eye. It is a good illustration of how to use angles to fix the positions of the various features in relation to each other. I have put in some construction lines to show how I go about it. Profiles are sometimes difficult to draw accurately without using this kind of procedure. You can see where I have made a number of corrections to the outline. The same is true of *Girl in Scarf*, an unfinished drawing which nevertheless illustrates two points: that looking up at your model can produce interesting results, and that a head-scarf eliminates the problem of what to do with the hair. I am frequently asked 'how do I draw hair?' It is noticeable that beginners often draw hair in a rather heavy, streaky manner. So perhaps if you feel that drawing hair is distracting you from the rest of your drawing – cover it up. When you can draw the model with a scarf you will probably find that drawing hair is much the same, in that you need to look for the general shapes and where the light falls, rather than tackling superficial effects which bear no relation to the structure

Mr Brown 8·8 cm × 6·3 cm—3½ in. × 2½ in.
B pencil on white cartridge

Heavily cross hatched drawing of man in front of a window. It is difficult to see a great deal of detail when the subject is in front of the light source, although there is usually a certain amount of reflected light falling on the face, and that alleviates the denseness of the tone

Profile in Shadow 13·3 cm × 10·7 cm—5¼ in. × 4¼ in.
2B pencil on white cartridge

Here the light was falling on the back of the girl's head and I was interested in the pattern of light and shadow on her profile

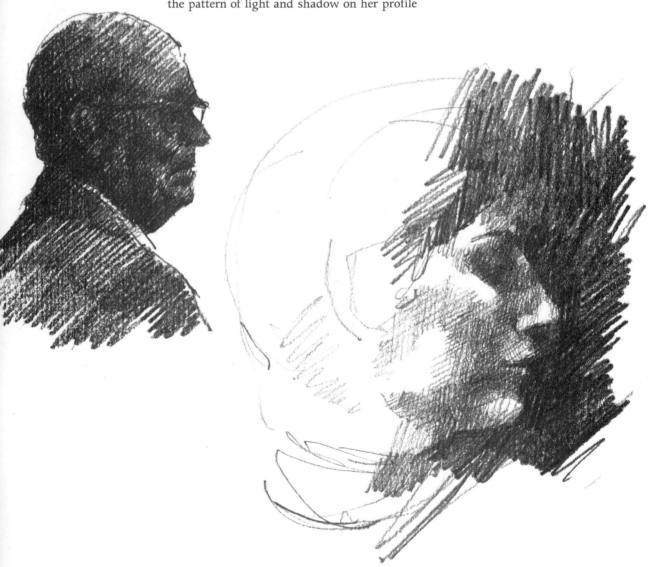

Man in a Crowd
8·8 cm × 8·2 cm—3½ in. × 3¼ in.
2B pencil on white cartridge

Altogether more decisive and characterful. The areas of tone are treated much more broadly and directly. The pose is interesting too, (see also page 32). If you ask your model to look over his shoulder or otherwise to twist himself round a bit, the head is naturally tilted and your drawing will have more movement and life about it

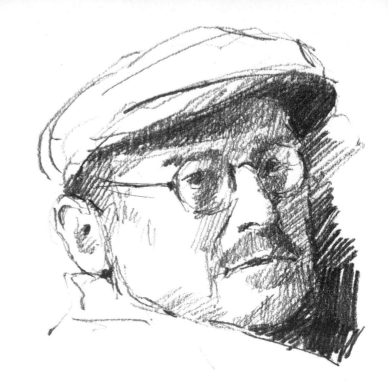

Arnold
13·9 cm × 10·7 cm—5½ in. × 4¼ in.
B pencil on white cartridge

Although the profile itself is not too bad, the cross hatching beneath the jaw and neck is overdone

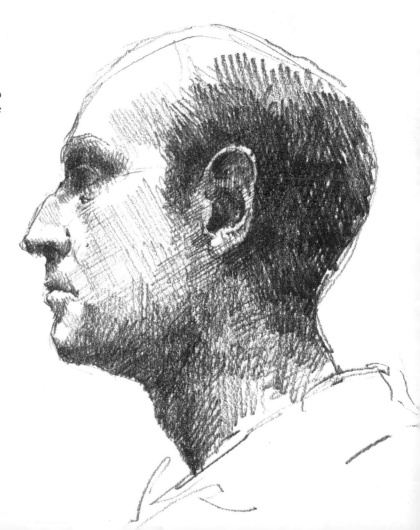

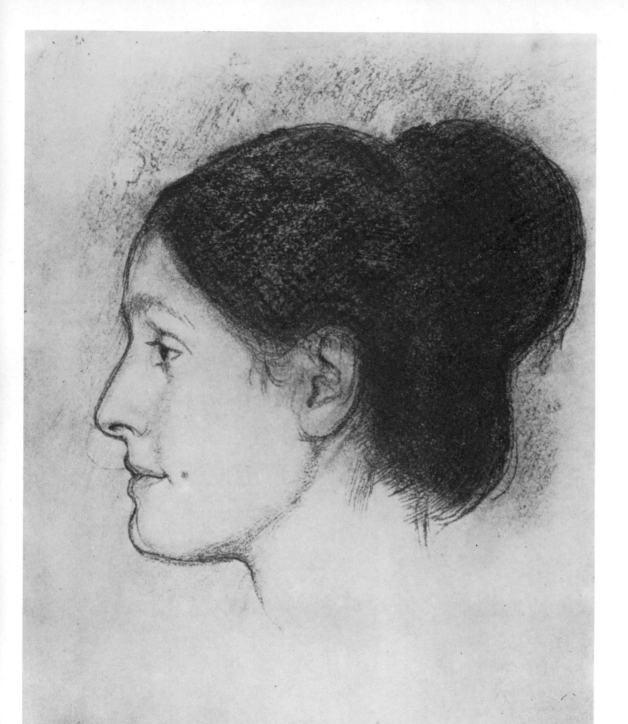

EDGAR DEGAS 1834–1917
Portrait of Mlle Hortense Valpinçon 22·8 cm × 15·8 cm—9 in. × 6¼ in.
Pencil and black pastel on white ground
Reproduced by permission of Dover Publications Inc, New York from facsimile
portfolio *Les Dessins de Degas* published by Demotte, Paris, 1922–23

Degas said, 'No art was ever less spontaneous than mine. What I do is the result
of reflection and study of the great masters: of inspiration, spontaneity, tempera-
ment I know nothing.' In this profile we can clearly see that faint lines were
first drawn, superseded by various other correcting lines. The black pastel has
been rubbed in last of all to give the rich darkness of the hair. Another example
of correcting lines adding life and movement to the drawing

Overleaf
SIR STANLEY SPENCER 1891–1959
Self Portrait 35·5 cm × 25·4 cm (14 in. × 10 in.)
Pencil on white paper
Reproduced by courtesy of the Trustees of the Victoria and Albert Museum,
London

Spencer has painstakingly delineated all the minute variations in tone and if it
were not for the sheer intensity and honesty of the observation, the drawing
would be rather dull. As it is, it has a strange compelling quality that immediately
takes our attention. The outline of the face strikes me as a bit heavy – it seems to
detach itself from the tone, especially on the right side. The hair is well drawn,
with a minimum of linear marks. Spencer did many self portraits – it would be
helpful to look at as many as you can to make comparisons and follow his
development

77

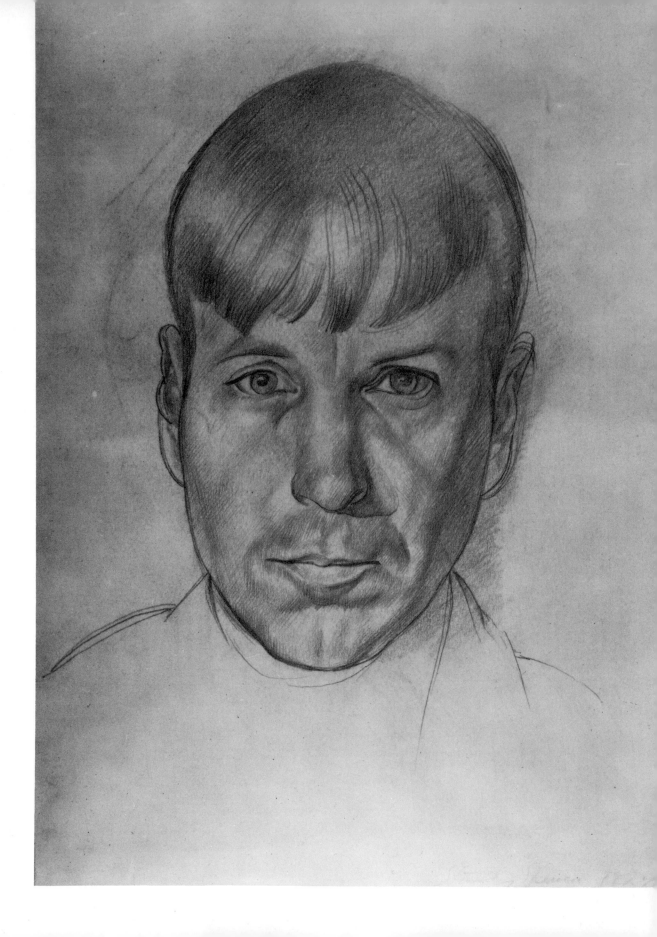

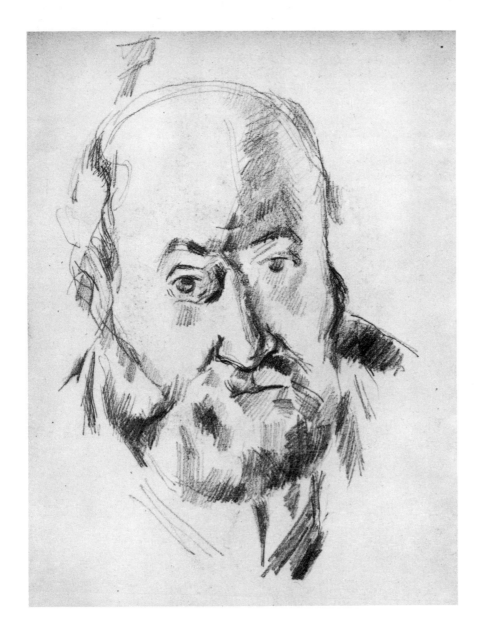

PAUL CÉZANNE 1839–1906
Self Portrait 22·2 cm × 12 cm—8¾ in. × 5 in.
Pencil on light ground
Reproduced by courtesy of The Art Institute of Chicago

Cézanne's method of shading is entirely different. He puts the tone on in patches
of varying weight in the same way as he applies touches of colour with square
brushstrokes in his paintings. Apart from being generally fascinated by this
drawing from a technical point of view, I am intrigued by the way he has
achieved different qualities of light. One side of the face is in direct light, the
other is in reflected light and to achieve this he makes the blank white paper
work just as hard as the terse, stinted patches of pencil

Four quick sketches all in 2B pencil on white cartridge paper

I find full-face portraits more difficult to draw than three-quarter view and the shapes are not normally so interesting to me. An asymmetrical arrangement is somehow easier to get in proportion. It is simpler to relate the features when they are actually connected instead of having to place them correctly within the outline of the head. If I am not careful I tend to get the eyes lopsided and wrongly spaced. When there is some movement in the pose as in the sketch below, where the girl is turning her head to look towards us, I feel much happier about tackling the job.

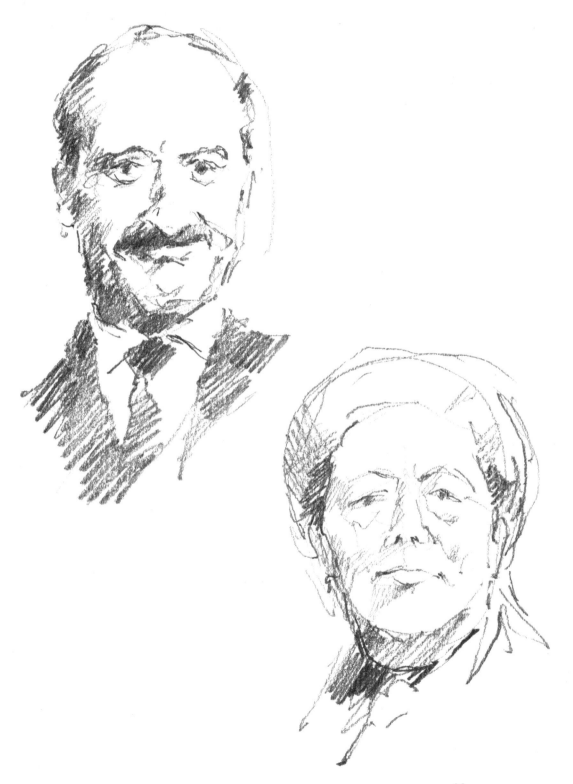

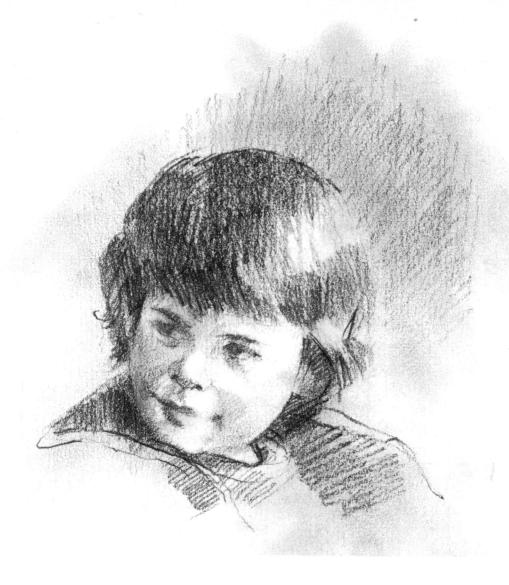

Nora 10·7 cm × 11·4 cm—4¼ in. × 4½ in.
Black Prince pencil on white cartridge

This type of pencil contains a waxy substance and consequently the line is quite
stiff to move across the paper compared with graphite. There are many different
densities and types of pencil and you will doubtless find, through experiment-
ing, which suits your purpose best

Benjamin 19 cm × 13·9 cm—7½ in. × 5½ in.
3B pencil on white cartridge paper

An appealing subject. I concentrated hard to get the earnest expression on the
child's face, and having achieved this, I now see many weaknesses in the
structure

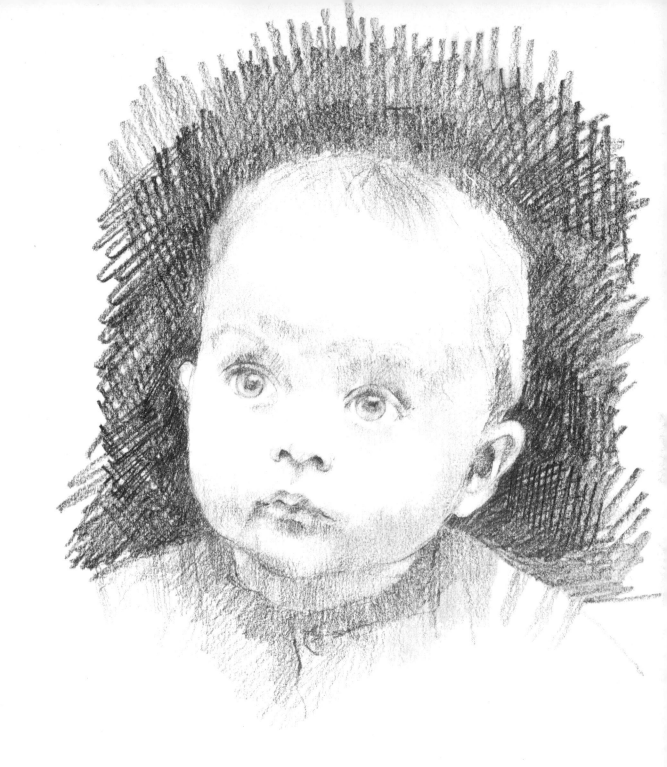

Pen and ink

Pens

In the old days, the artist used quill or reed which he cut to suit his personal requirements. It is perhaps worth experimenting with such tools, though I daresay it takes a bit of practice to get the hang of it. Generally, of course, we use a steel nib in a pen-holder. There are numerous different sorts of nib from which to choose – Gillott's 303 is probably the most popular and it is the one I normally use. All my illustrations were drawn with it except in a few cases which I have specified. The important thing about a drawing nib is that it should be reasonably flexible and capable of producing different thicknesses of line. A fountain pen is useful for sketching but the nib is usually rigid, although a shorthand nib is worth trying. It is a matter really of finding the pen that suits you best.

Ink

Black Indian ink and sepia are normally used for drawing with a dip-pen, but such waterproof inks are not suitable for a fountain pen. Indian ink tends to thicken with age – I have noticed that when I have had a half-empty bottle hanging about for some time the ink does not flow so freely from the nib. Ordinary writing ink does not give the intense opaque black that you get with Indian ink – also it is likely to fade in time, so it is as well to use it mainly for sketching.

Paper

Do not use paper that is too thin or soft for pen drawing – you are very likely to wear a hole in it. However, as you will probably use up a great deal of paper until you get used to pen and ink drawing, you might try to cadge some computer printouts and use the back of these as the paper is of very good quality.

Overleaf
Sir Stanley Spencer 1891–1959
Self Portrait 21·5 cm × 35·5 cm—8½ in. × 14 in.
Pen and ink on brownish paper
Reproduced by courtesy of Anthony d'Offay and Sir John Rothenstein

Honoré Daumier 1808–79
Head of a Man
Pen and ink on light ground
Reproduced by courtesy of the Wadsworth Atheneum, Hartford, Connecticut
Gift of Henry Schakenberg

These two illustrations show contrasting ways of drawing in pen and ink. Spencer has used heavy, straight strokes, cross hatched again and again. This drawing was done on top of a sheet of studies and it is difficult to tell what type of ink was used. It is mainly sepia with a wash on the right side of the head of a blue/black colour, this also comes through in other parts where the ink is worked heavily. It shows again the intense concentration and painstaking effort we saw in Spencer's pencil sketch.

Daumier on the other hand uses a thin spidery line – his strokes are much more fluent and generally curved – to describe the forms of the head for instance around the eyes and chin. The cross hatching is of an entirely different character and there is no outline as such. The head has a remarkable roundness and solidity despite the tangle of apparently random marks. There are never any straight strokes in Daumier's drawings; he often worked from memory

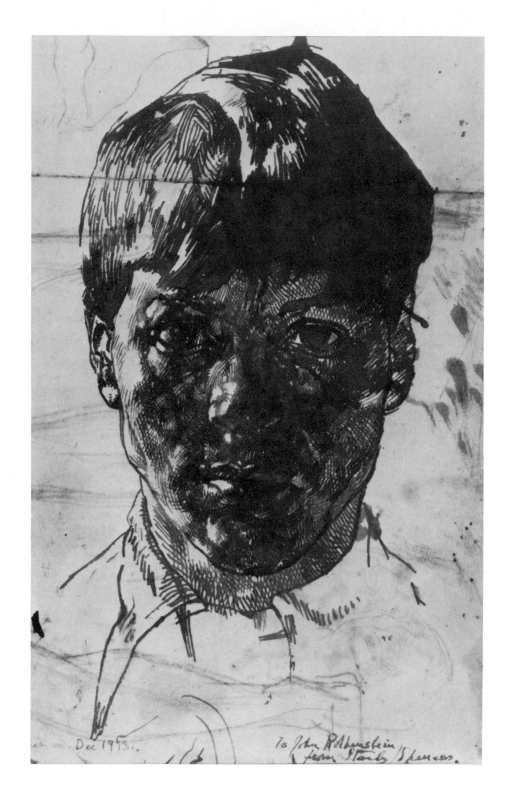

Dec 1943.

To John Rothenstein
from Stanley Spencer.

86

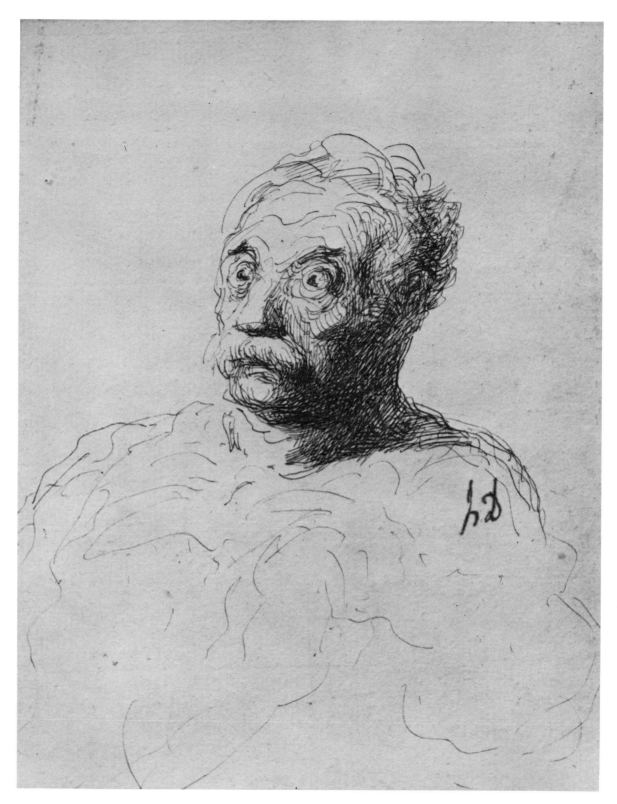

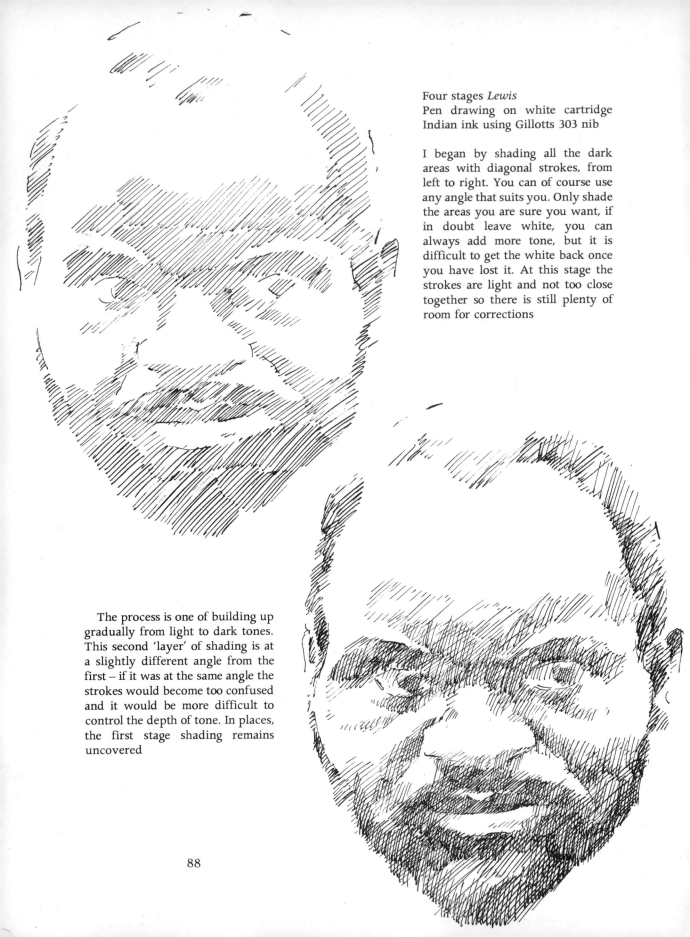

Four stages *Lewis*
Pen drawing on white cartridge
Indian ink using Gillotts 303 nib

I began by shading all the dark
areas with diagonal strokes, from
left to right. You can of course use
any angle that suits you. Only shade
the areas you are sure you want, if
in doubt leave white, you can
always add more tone, but it is
difficult to get the white back once
you have lost it. At this stage the
strokes are light and not too close
together so there is still plenty of
room for corrections

The process is one of building up
gradually from light to dark tones.
This second 'layer' of shading is at
a slightly different angle from the
first – if it was at the same angle the
strokes would become too confused
and it would be more difficult to
control the depth of tone. In places,
the first stage shading remains
uncovered

88

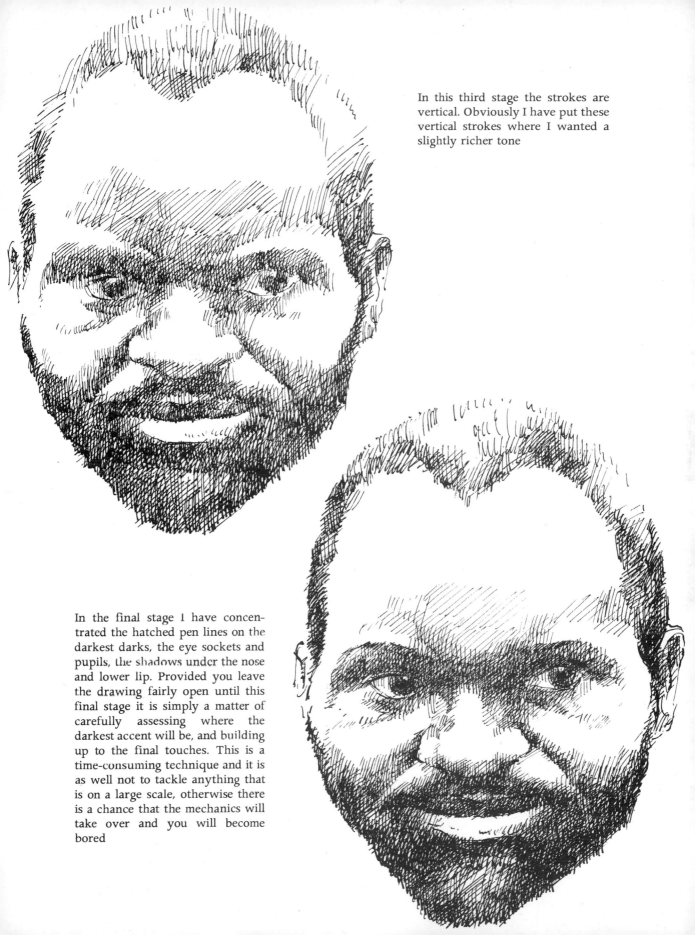

In this third stage the strokes are vertical. Obviously I have put these vertical strokes where I wanted a slightly richer tone

In the final stage I have concentrated the hatched pen lines on the darkest darks, the eye sockets and pupils, the shadows under the nose and lower lip. Provided you leave the drawing fairly open until this final stage it is simply a matter of carefully assessing where the darkest accent will be, and building up to the final touches. This is a time-consuming technique and it is as well not to tackle anything that is on a large scale, otherwise there is a chance that the mechanics will take over and you will become bored

Angela 12 cm × 10 cm—4¾ in. × 4 in.
Gillotts 303 nib Indian ink on white cartridge

This is a simple study in light and shade with orderly, regular criss-cross shading.
It is built up in the same way as *Lewis* (pages 89–90). I deliberately arranged the
shadow into a dark oval

Walter 10 cm × 6·5 cm—4 in. × 2½ in.
Script pen Indian ink on cartridge

This drawing was done with a script pen. It is rather a stiff, clumsy effort, with
too much shading in the lower half of the face. When you put tone on a drawing
it must be with a purpose: to show a change in plane, to explain the solidity of
the form. Here the cross-hatching does not do anything useful at all – it just looks
as though he has been in a mud-bath up to his nose

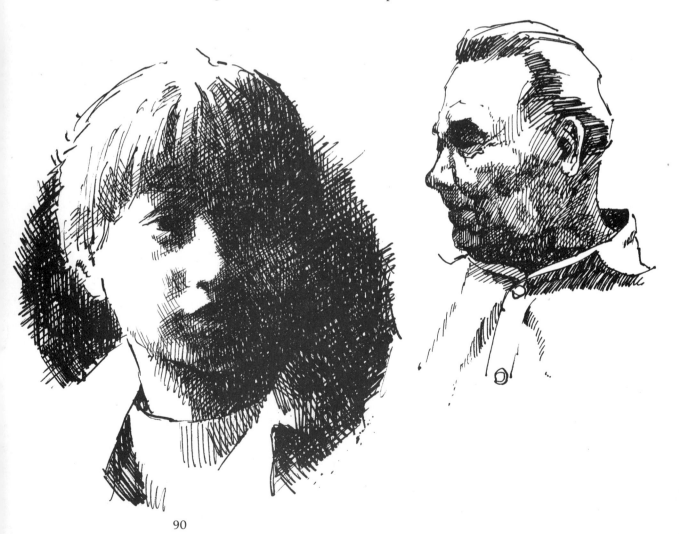

Through the Window 11·4 cm × 7·6 cm—4½ in. × 3 in.
Gillotts 303 nib Indian ink on white cartridge paper

I tried to do this using just diagonal hatching but abandoned it after a while. The
strokes tend to get confused with one another and dark accents appear where I
do not want them – it is much more difficult to get the degree of subtlety that is
possible with cross-hatching

Old Man 10 cm × 11·4 cm—4 in. × 4½ in.
Gillotts 303 nib black Indian ink on white cartridge paper

This more irregular type of cross-hatching with the strokes going in all directions
is the way I normally work, especially when sketching. I think it gives a much
more lively effect than other drawings on these two pages

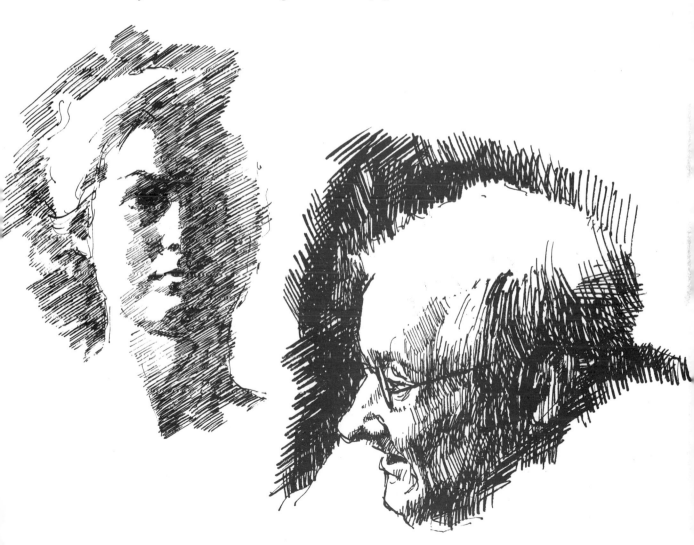

The Farmer 10·7 cm × 7·6 cm—4¼ in. × 3 in.
Black fountain-pen ink on white cartridge

Here I have used a zigzag scribbly shading which gives a pleasing effect. Never overdo the hatching to the extent that you cover all the paper – it is those little specks of white showing through that give luminosity to the shadows and stop them becoming too dense. And, of course, it is the contrast of black and white that makes a pen drawing so rich and dramatic

Mrs Fantoni 11·4 cm × 8·8 cm—4½ in. × 3½ in.
303 Gillots nib Indian ink on white cartridge

Nothing dramatic about this drawing
– just a simple portrait sketch mainly in line

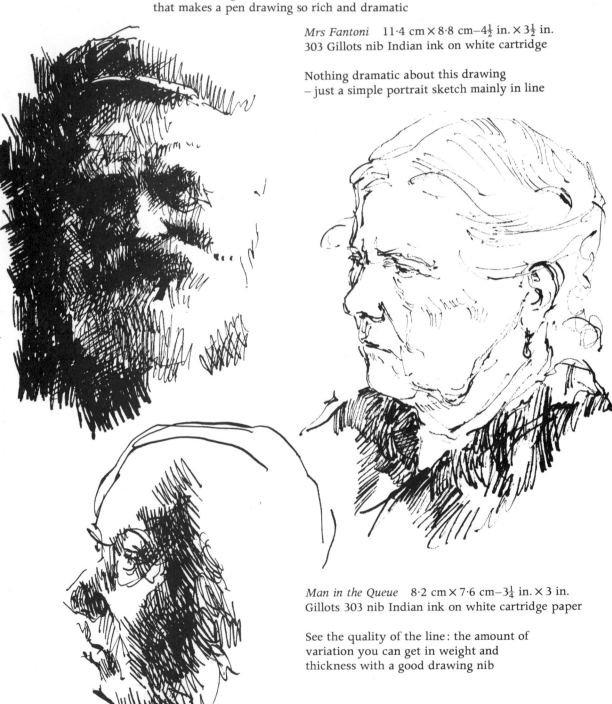

Man in the Queue 8·2 cm × 7·6 cm—3¼ in. × 3 in.
Gillots 303 nib Indian ink on white cartridge paper

See the quality of the line: the amount of
variation you can get in weight and
thickness with a good drawing nib

Mr Green 16·5 cm × 10 cm—6½ in. × 4 in.
Pen drawing with Gillotts 303 nib on green/grey Ingres paper highlights added
with Chinese white

This is a straightforward pen drawing with highlights added in white paint. Do
not use too much water with the paint or it will not show, and do not overdo the
white – if too much of the paper is covered the effect will be lost. The mechanics
of the drawing are much the same as those illustrated in the toned drawings in
section I and, of course, you can use chalk for the highlights instead of white
paint

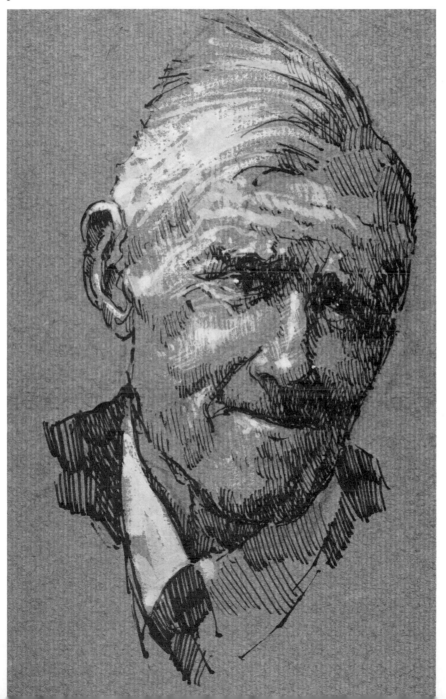

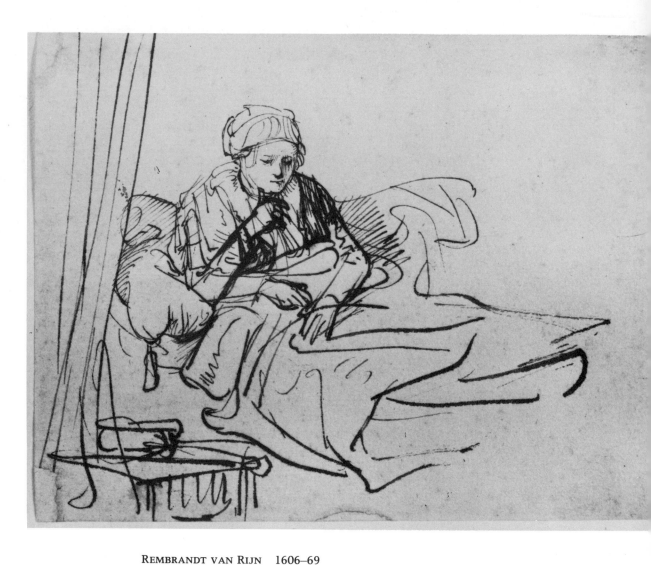

REMBRANDT VAN RIJN 1606–69
Young Woman in Bed 14·9 cm × 19 cm—5$\frac{7}{8}$ in. × 7$\frac{1}{2}$ in.
Reed pen and ink on light ground
Reproduced by courtesy of the Groninger Museum, Groninger, The Netherlands

We tend to be nervous of pen and ink because it cannot be rubbed out if a
mistake is made. But once you have become used to it, it is a most enjoyable
medium for sketching, as well as for more finished drawing. I think it has a much
more free-flowing and expressive line than pencil

The vivid spontaneous drawings by Rembrandt illustrate the right approach.
Young Woman in Bed, for instance, shows a fairly soft, broad line and the drawing
loses nothing by having drastic alterations made to it, in fact they give added
richness and interest. *Woman three-quarter profile* (page 96) is drawn with a thin
serpentine line which moves with such ease and grace it would almost appear that
Rembrandt was doodling without lifting his pen from the paper

94

Pen and wash and brush

Pen and wash

'Wash' in this case is ink diluted with water. We are normally advised to use distilled water because tap water tends to make the ink particles separate out instead of producing an even wash – however I do not think it makes all that difference and I am happy to use ordinary water.

The combination of ink, line and wash has been popular with artists over the centuries: it is capable of a wide range of effects and is particularly useful for subjects with strong tonal contrast.

Some interesting results can be obtained with writing ink: since it is not waterproof you can easily alter your drawing, tone down any lines that seem too strong, or soften the edges of washes. The same can be done with felt- or nylon-tipped pens.

Brush drawing

Under this heading I include wash drawings, whether in ink or watercolour, where the pen line is not used. Of course, you can do a brush drawing entirely in line and I have an example of that too.

A wash made with waterproof ink cannot be shifted once it is dry, whereas with watercolour or non-waterproof ink you have a little more leeway. In either case you may prefer to work out the main shapes in pencil or chalk to start with, but it is fatal to do a very detailed pencil drawing and just fill it in with wash. I like to get stuck in straight away with the brush! As long as you keep the washes light at first, you can still make corrections as you go along. Use a sable watercolour brush with a good point and buy the best you can afford.

Paper

Good quality paper is expensive but it will stand up to rather more rough treatment and it is worth getting the best you can afford. For the benefit of anyone who does not know, watercolour paper comes in three types: 'rough' which is well textured, 'hot pressed' which is smooth, and 'not' or 'cold pressed' which is somewhere between. Thickness is indicated by the weight per ream, for instance: 145 grammes per square metre – 72 lb, 300 g/m^2 – 140 lb and so on. The thicker the paper, the less likely it is to buckle when it is wet. If you are using ordinary cartridge paper, it is as well to stretch it first. This is simply a matter of soaking it in a bath for a few minutes so it expands, then fixing it all round the edges, onto a board, using gumstrip. As it dries it contracts again and will remain flat and wrinkle-free for the duration of your drawing.

EDGAR DEGAS 1834–1917
The Ballet Master 48·2 cm × 30·5 cm—19 in. × 12 in. colour plate facing
Oil drawing on greenish/ochre paper
Reproduced by permission of Dover Publications Inc, New York from facsimile
portfolio *Les Dessins de Degas* published by Demotte, Paris, 1922–23

Many of Degas' drawings were in oil on tinted grounds. He worked the paint
thinly with plenty of turpentine. This appears to be drawn in lamp black and
white with Venetian red or possibly burnt umber. This technique allows greater
freedom of movement. It is better to draw standing up when working in this
way unless your support is small. I find it is best to rub over the surface of the
paper first with white spirits which gives a better surface on which to work.
There seems to be a body of opinion to support the view that oil paint on paper
deteriorates quickly. I have not found this to be true. Degas, Rubens, Tiepolo
and many other Masters used this technique for sketches and they seem to be
standing the test of time See also text page 117

REMBRANDT VAN RIJN 1606–69
Woman three-quarter profile facing right 10 cm × 6·2 cm—4 in. × $2\frac{1}{2}$ in.
Reed pen on light ground
Reproduced by courtesy of Museum Boymans – van Beuningen, Rotterdam

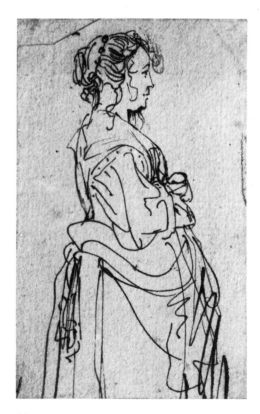

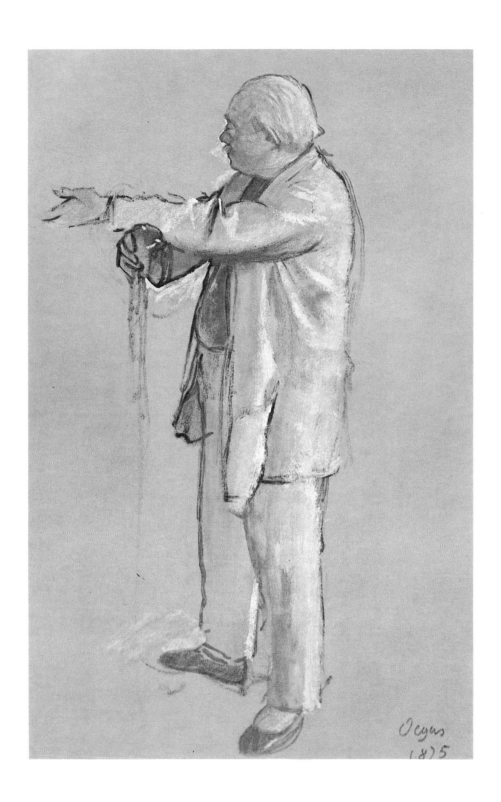

REMBRANDT VAN RIJN 1606–69
Man in Tall Hat 16·8 cm × 12·5 cm–6$\frac{5}{8}$ in. × 4$\frac{7}{8}$ in.
Pen and wash on light ground
Reproduced by courtesy of The British Museum, London

Rembrandt is equally free and easy in his approach to pen and wash. Here can be seen the advantage of using brush when drawing subjects with strong light and shadow. Using only pen it would take a great deal of drawing to obtain the same depth of tone which can be achieved with just one brush full of ink

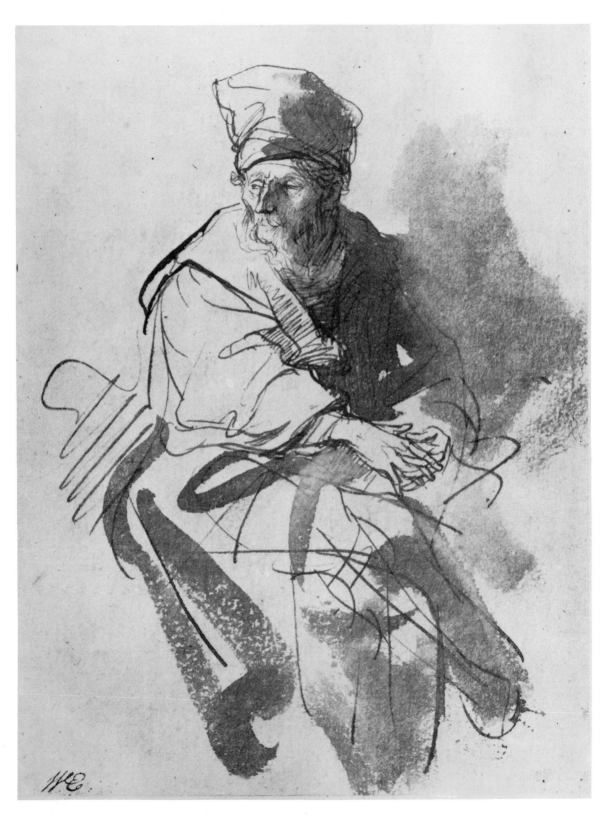

Five stages *Sitting in the Sun* 16·5 cm × 10 cm—6½ in. × 4 in.
Pen and wash Gillotts 303 pen and Indian ink on hot pressed white paper

For pen and wash I have my paper supported at a slight tilt. I like to start by putting in main areas of tone with a light wash – then drawing into it with pen while it is still wet. This softens the lines, which is an advantage at this early stage. I then carry straight on with the next (darker) wash. Unlike the first I do not leave it as a simple flat wash, but introduce less diluted ink here and there (working wet on wet.) I then usually leave it to dry, (it does not take long,) before adding finishing touches, strengthening lines here and there, adding darker tones if necessary. Wet on wet makes for greater vibrancy, varies the tone and creates more interest. An ink drawing where each wash is painted on flat and allowed to dry before adding the next tends to be somewhat dull. Keeping washes fluid makes the most of the special qualities of the medium – rich darks capable of dramatic effect. Load your brush with plenty of wash and let it run fairly free. I normally use china saucers (plastic causes the wash to separate which irritates me). I have three or four with varying densities of water and ink in each so that I can work quickly

Stage 1

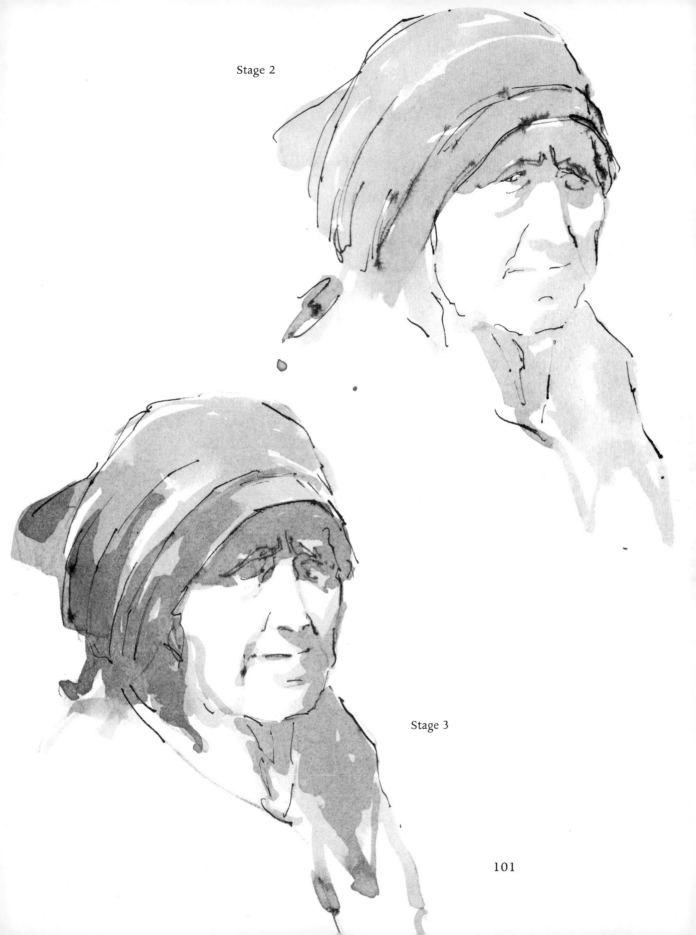

Stage 2

Stage 3

101

Stage 4

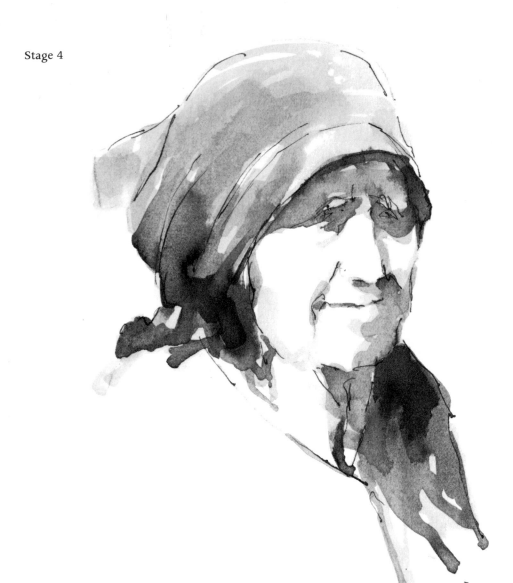

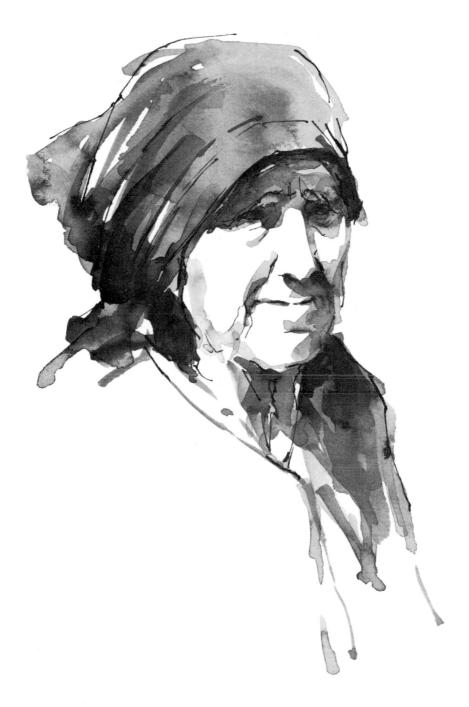

Maybe 11·4 cm × 8·8 cm—4½ in. × 3½ in.
Pen and wash in Indian ink on white cartridge

Developed from a pen drawing in my sketchbook. I finished it later from
memory, adding wash, then cross-hatching on top with the pen

Margo 13·9 cm × 14·6 cm—5½ in. × 5¾ in.
Pen and wash on cartridge paper

Illustrates the subtle variations in tone that can be achieved with wash. Here the
pen line is relatively unimportant. You can see by the hard edges of the washes
that each was allowed to dry before adding more

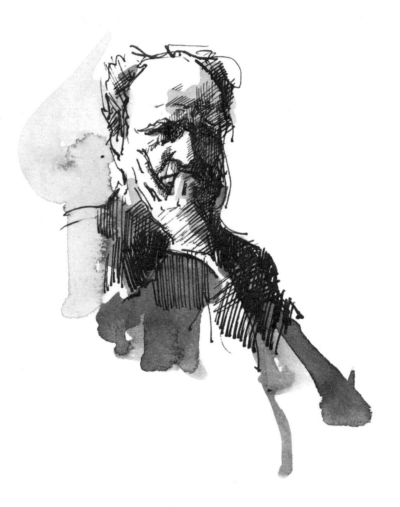

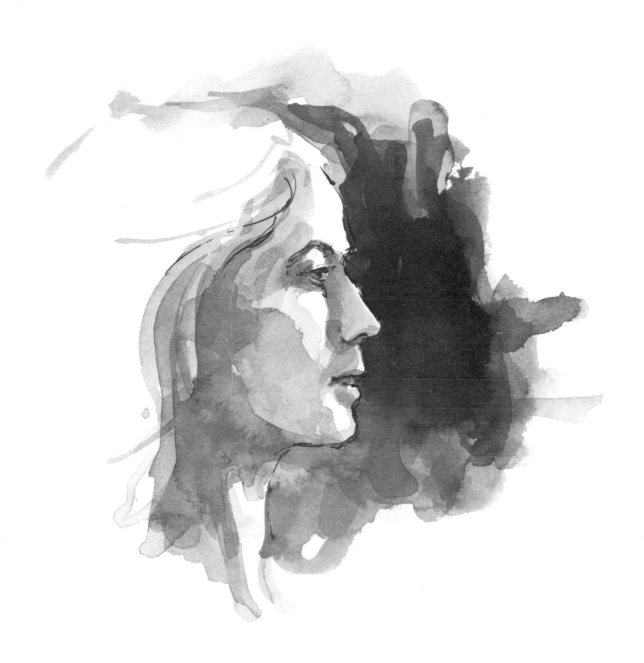

HENRY MOORE, OM born 1898
Portrait of the Artist's Mother 1927 27·3 cm × 17·7 cm—10¾ in. × 7 in.
Pen, pencil, ink wash, finger rubbing and scraping on white cartridge
Reproduced by courtesy of Henry Moore

To get this rich and painterly effect, Henry Moore has used a variety of marks.
He has rubbed the ink with his fingers to make a blurred edge to the skirt as it
changes plane across the knees which works quite beautifully; apart from
giving a satiny effect, the blurring helps the form to recede – a hard edge would
have had the opposite effect. Reflected light down the left hand side of the face
and dress have been scraped, probably with a razor blade, so that the white
ground shows through the ink wash

REMBRANDT VAN RIJN 1606–69
Youth in Large Hat 8·4 cm × 8·8 cm—3¼ in. × 3½ in.
Brush drawing
Reproduced by courtesy of the Trustees of the British Museum, London

It is possible to do a portrait without really showing the face. You can simply
capture the subject's particular attitude. Attitude is an important part of a
portrait and you should try to capture this as well as the specific features.
Notice the strong, sure line, applied with constant speed and pressure

The Musician 12 cm × 8·8 cm—4¾ in. × 3½ in.
Indian ink pen and wash on white cartridge

In this drawing you can see the way I have drawn into the wet washes with a pen, especially round the eyes and mouth and on the hair

Mr Mosley 19 cm × 12·7 cm—7½ in. × 5 in.
Pen and Indian ink wash on white cartridge

I drew a good deal in pen on top of the preliminary wash in this case, then finished off with more washes. A word in passing about proportion. You will notice that the distance from the top of the cap to the chin is slightly greater than that from the chin to the waistband of the trousers. That is perhaps rather unexpected, but you have to look out for the unexpected when you are drawing people because they can sometimes contort themselves into the most improbable positions and it plays havoc with the proportion!

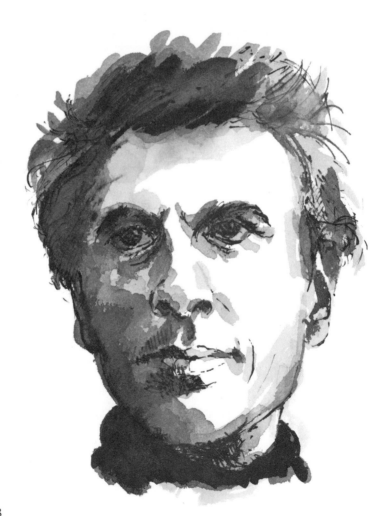

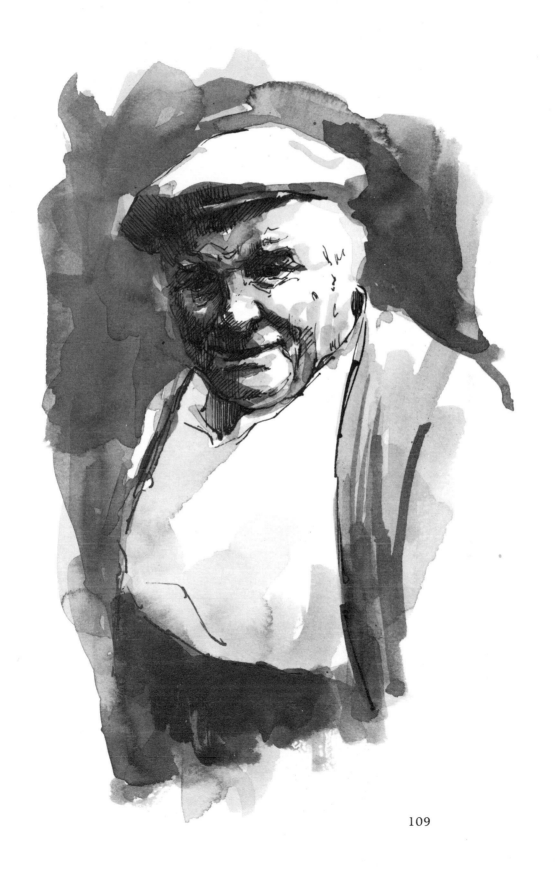

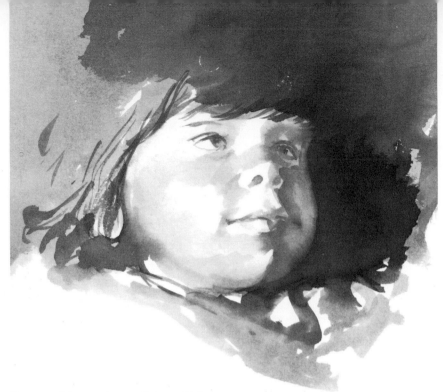

Rupert 12 cm×9 cm—4¾ in.×3½ in.
Non-waterproof fountain-pen ink on white cartridge paper

These two drawings were made with a brush using washes of black writing ink which I find a pleasant medium to use, though perhaps not entirely satisfactory if you want posterity to enjoy your work. When diluted with water, the ink breaks down into brownish and bluish tones. It gives a good luminous wash and is not unlike watercolour to handle – and, of course, you can obtain a good rich dark colour. These studies were made with the child's attention firmly fixed on the television otherwise he probably would not have sat still long enough

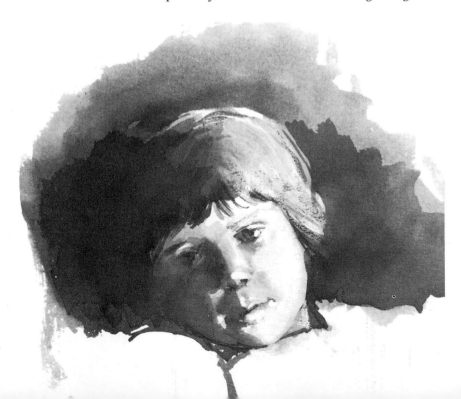

The Actor 20·9 cm × 20·3 cm—8¼ in. × 8 in.
Brush and Indian ink with touches of white conté on white Ingres paper

Another study in light and shadow, this time done in a flat wash of undiluted
Indian ink over a preliminary chalk drawing, I added a bit of white conté very
lightly to the sides of the face and nose just to alleviate the denseness of the tone

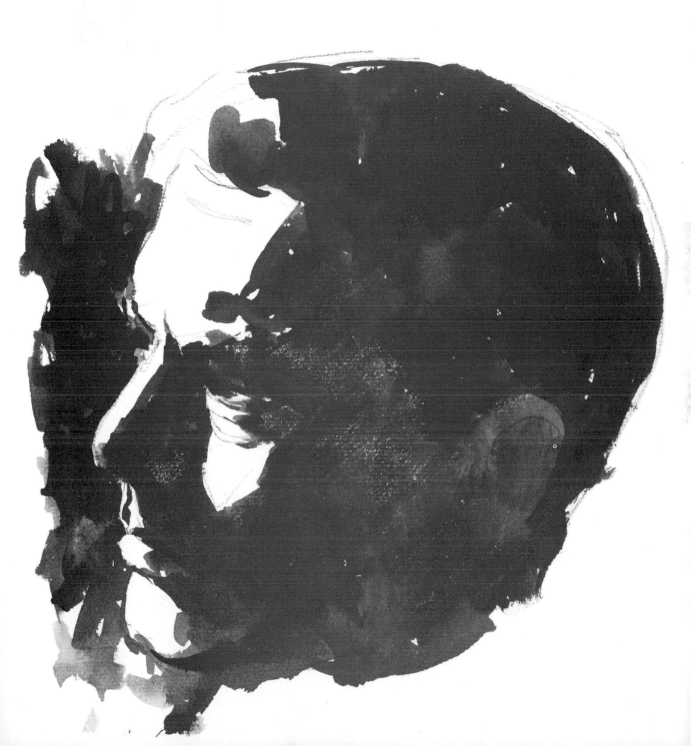

Brenda 19 cm × 19 cm—7½ in. × 7½ in.
Sepia ink on hot pressed watercolour paper 192 g/m²—90 lb

This study was built up from light washes applied with a sable brush. I mixed up four different tones in separate saucers beforehand – this allowed me to concentrate on the washes on the paper rather than the washes in the saucer. I first dampened the area of paper I was working on then put on a faint wash, allowed that to dry then gradually introduced darker areas – making sure that each wash was completely dry before going on with the next. In this type of technique I would advise you to begin at least six studies. You are not then tempted to work on the washes before they are dry, but can keep up a continuous flow from one study to the next

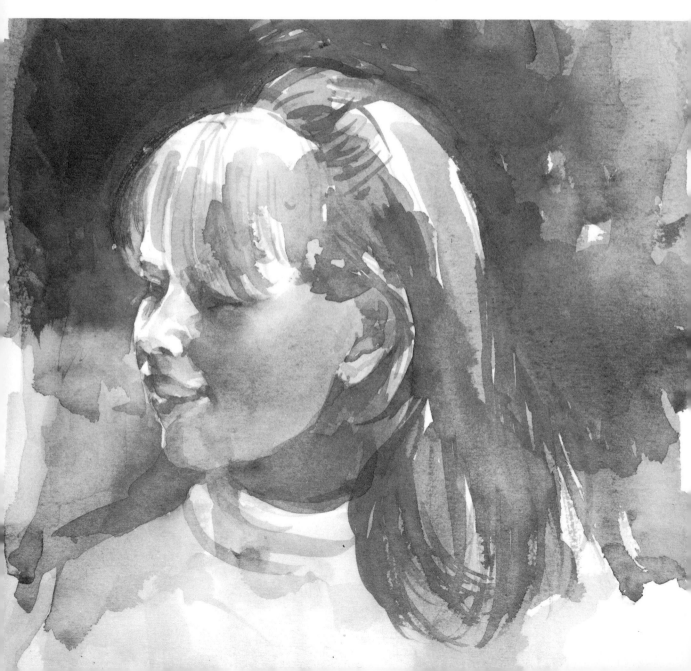

The Spy 20·3 cm × 15·2 cm—8 in. × 6 in.
Burnt umber watercolour on white 'not' paper

Rather a tired drawing of a tired looking person. The washes are muddled, especially on the right side of the face where they do nothing to explain the form. I should have left more white paper on the cheekbone for instance – that strip of tone cutting across from below the right eye is no help at all. The thing is, I was indecisive about where, or where not, to put my washes

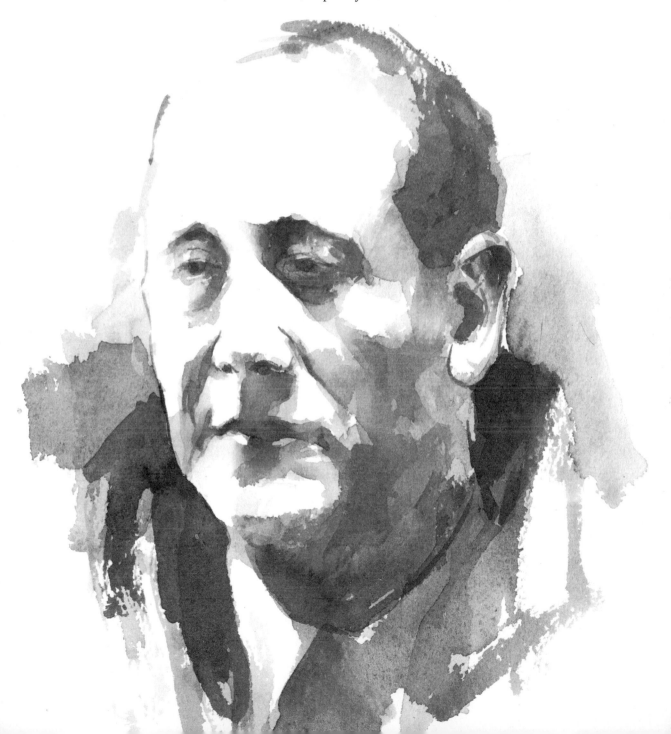

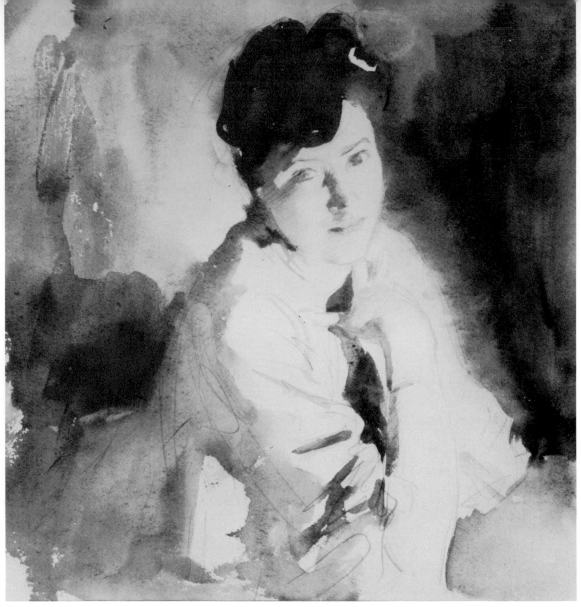

These two drawings are made in the same medium and it is instructive to compare
how differently each artist has treated the subject. Augustus John always said
that his sister was the better artist. Here she has treated the composition and
lighting very simply by applying three flat areas of wash for the background
and skirt with dark, almost undiluted pigment on the hair and scarf. The head is
modelled in pencil with touches of brush wash on the features and blouse.

Sargent, on the other hand, has made an impressionistic study in light and
shade with great skill and assurance. Notice how he softens the edge of the
washes on the face and blouse, and the luminous quality he has achieved by
playing up the lights and darks against each other

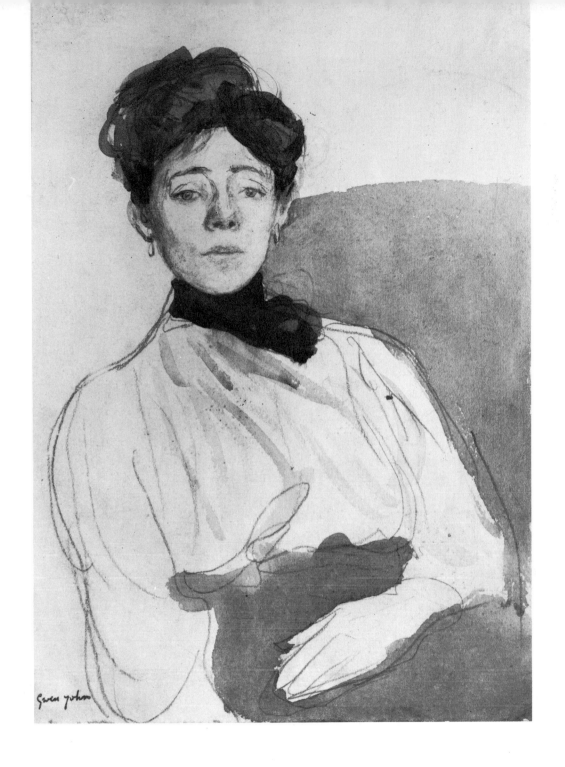

GWEN JOHN 1876–1939
Portrait of a Lady 25·4 cm × 17 cm–10 in. × 6¾ in.
Pencil wash on light ground
Reproduced by courtesy of Davis and Long Company, New York

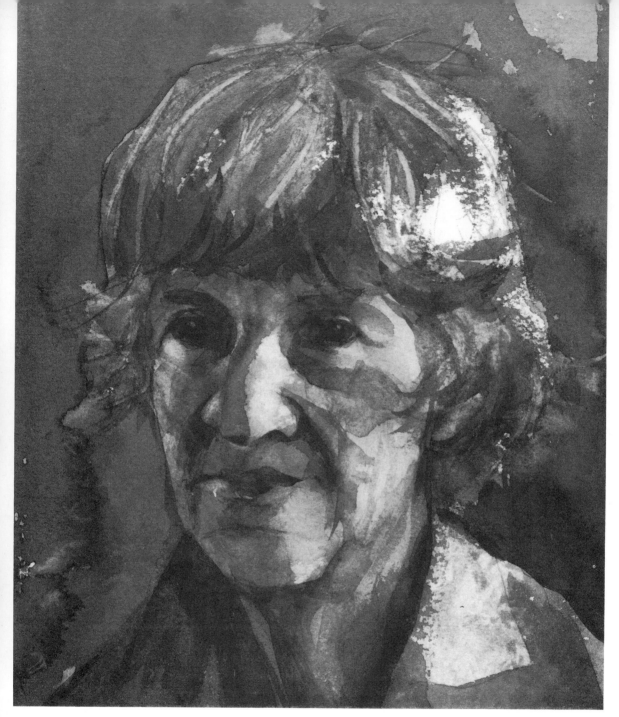

Miss Hamilton 22·8 cm × 13·9 cm–9 in. × 5½ in.
Watercolour on 'not' 300 g/m²–140 lb watercolour paper

Although this is a good likeness, there are, unfortunately too many hard edges. When working in watercolour it is essential to 'lose' some of the edges which occur as the wash dries. This you can do by blotting with a tissue or softening with a clean wet brush. The lights in the hair were put on with the wrong end of the brush whilst the paint was still wet, there are also dry brush marks in the hair

116

Oil and acrylic sketches on paper

The fuss and expense of preparing canvas and boards can be daunting – getting on with the work is the priority here, so why not use paper. Better to do a dozen study sheets than one canvas which may well be intimidating from the start.

When working in acrylic I mix up a mid tone of whatever colour I choose, and brush a coat of this all over the paper and let it dry. This base is also suitable for oils. Otherwise (for oils) I choose a coloured paper and brush a coat of white spirit all over the surface. This allows the paint to flow more freely as dry, untreated paper soaks up oil very quickly. I also use plenty of turps as a medium whilst working in oils on paper.

The only disappointments I have had regarding oil sketches were those I discovered recently whilst clearing out my old studio. They had been done on oil sketching paper some twelve years ago. I found that it had split and cracked so much that the work was useless. Other oil sketches stored in the same place and mainly done on cheap cartridge or sugar paper were still in good condition.

Paper is a strong material to which Chinese drawings many hundreds of years old testify. You can scratch it with steel nibs, flood it with water and pigment, saturate it with spirits and still it will support and reflect your ability.

See example, Degas' *The Ballet Master,* colour plate facing page 96.

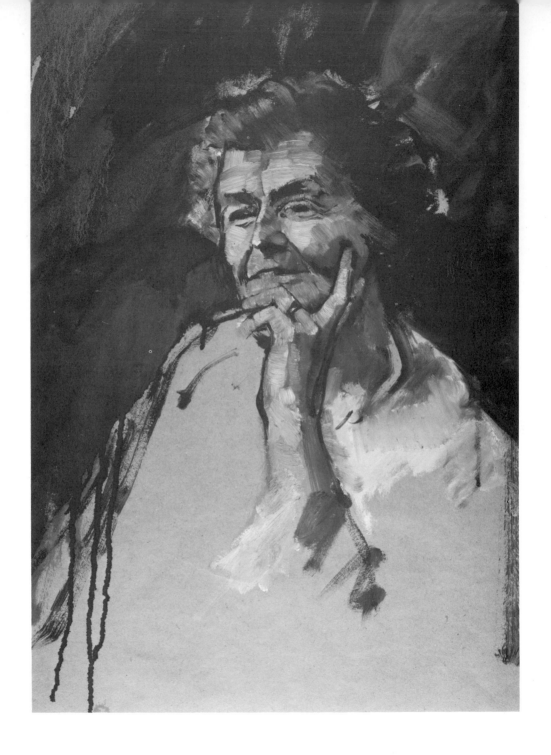

Aunty Mary 47·6 cm × 31·7 cm—18½ in. × 12½ in.
Burnt sienna and white oil paint on buff coloured sugar paper

This drawing was made several years ago and as yet shows no sign of ill effects, although it was done on poor quality paper and the paint is thick in places, particularly the lighter tones on the face and hands

118

Suppliers

Great Britain

L Cornelissen and Sons
22 Great Queen Street
London WC2

Cowling and Wilcox Ltd
26 Broadwick Street
London W1

Crafts Unlimited
(Reeves-Dryad)
178 Kensington High Street
London W8

11–12 Precinct Centre
Oxford Road
Manchester 13

202 Bath Street
Glasgow C2

Dryad Limited
Northgates
Leicester LE1 4QR

George's
52 Park Street
Bristol 1

The Midland Educational
 Company Limited
583 Moseley Road
Birmingham B12 9BW
and Branches at Coventry,
Leicester and
Wolverhampton

Clifford Milburn Limited
54 Fleet Street
London EC4

Miller's (Art and Craft) Ltd
54 Queen Street
Glasgow G1 3DH

Reeves and Sons Limited
Lincoln Road
Enfield
Middlesex

Robersons and Company
Limited
71 Parkway
London NW1

George Rowney and
 Company Limited
10 Percy Street
London W1

Wheatsheaf Art Supplier
59 Exmouth Market
London EC1

Winsor and Newton Limited
51 Rathbone Place
London W1

United States

Arthur Brown and Bros Inc
2 West 46 Street
New York, NY 10036

A I Friedman Inc
25 West 45 Street
New York, NY 10036

Grumbacher
460 West 34 Street
New York

The Morilla Company Inc
43 21 Street
Long Island City
2866 West 7 Street
Los Angeles, California

New Master Art Division
 California Products
 Corporation
169 Waverley Street
Cambridge, Massachusetts

Stafford-Reeves Inc
626 Greenwich Street
New York, NY 10014

Steig Products
PO Box, 19, Lakewood
New Jersey 08701

Winsor and Newton Inc
555 Winsor Drive
Secaucus, New Jersey 07094

See Yellow Pages for your nearest Artists' Colourmen

Index

Figures in *italic* refers to illustrations